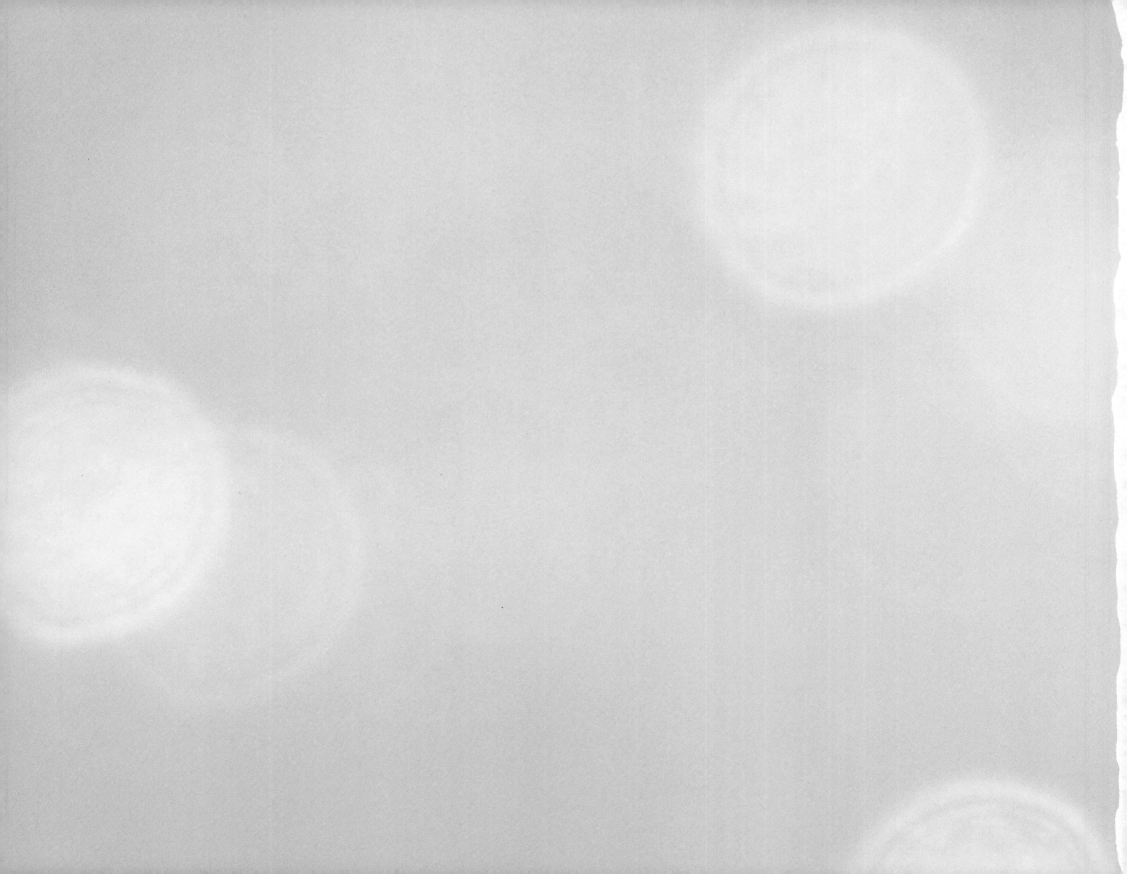

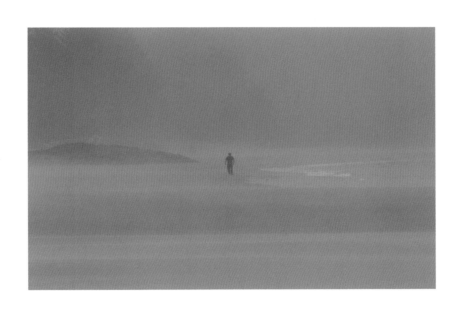

FOR JOHN, THE CENTER OF MY WALK THROUGH THE WORLD,
AND TO BEN AND JOCIE WHO FILL OUR LIVES WITH JOY.

SANDI HABER FIFIELD WALKING THROUGH THE WORLD

ESSAYS BY ARTHUR OLLMAN AND TOM O'CONNOR

DESIGN BY KAREN SALSGIVER

Sandi Haber Fifield
9.17.09

CHARTA

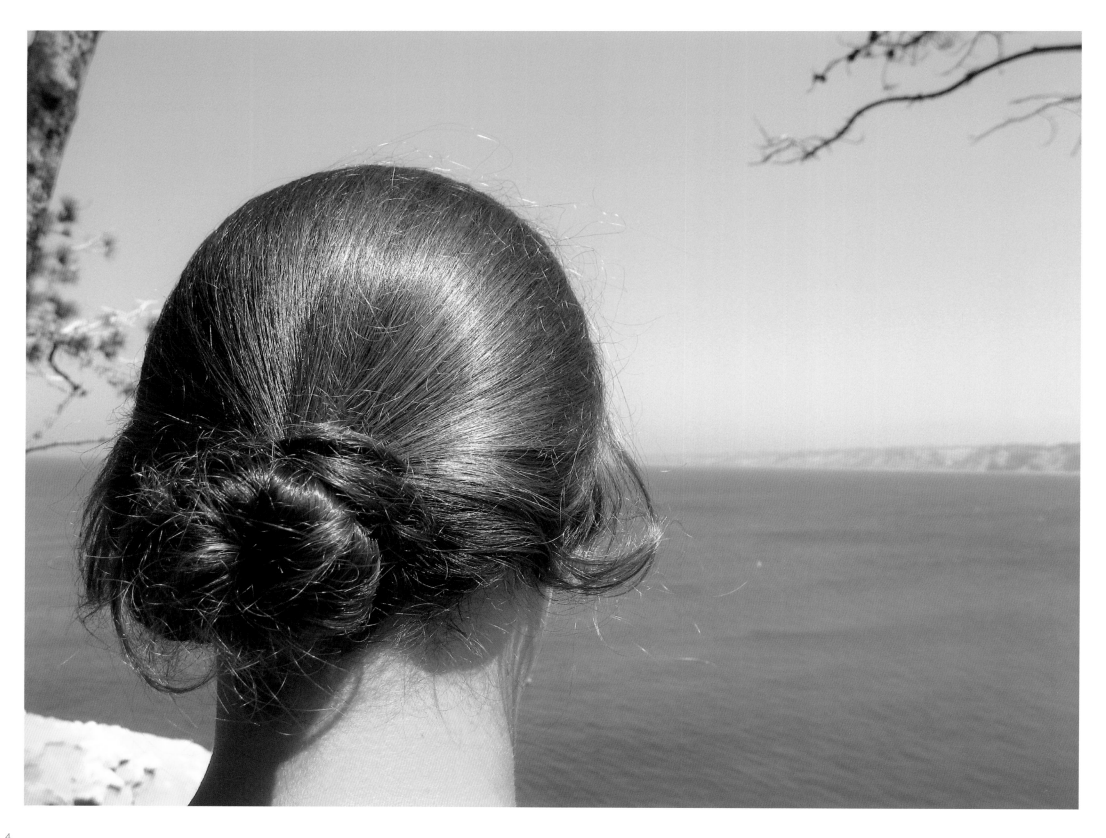

A PHOTOGRAPH IS NOT THE POSSESSION OF A MOMENT;

IT IS THE MOMENT BETWEEN BEFORE AND AFTER.

IT'S FRAGILE FROM INTERPRETATION AND CERTAINTY.

OWEN BUTLER

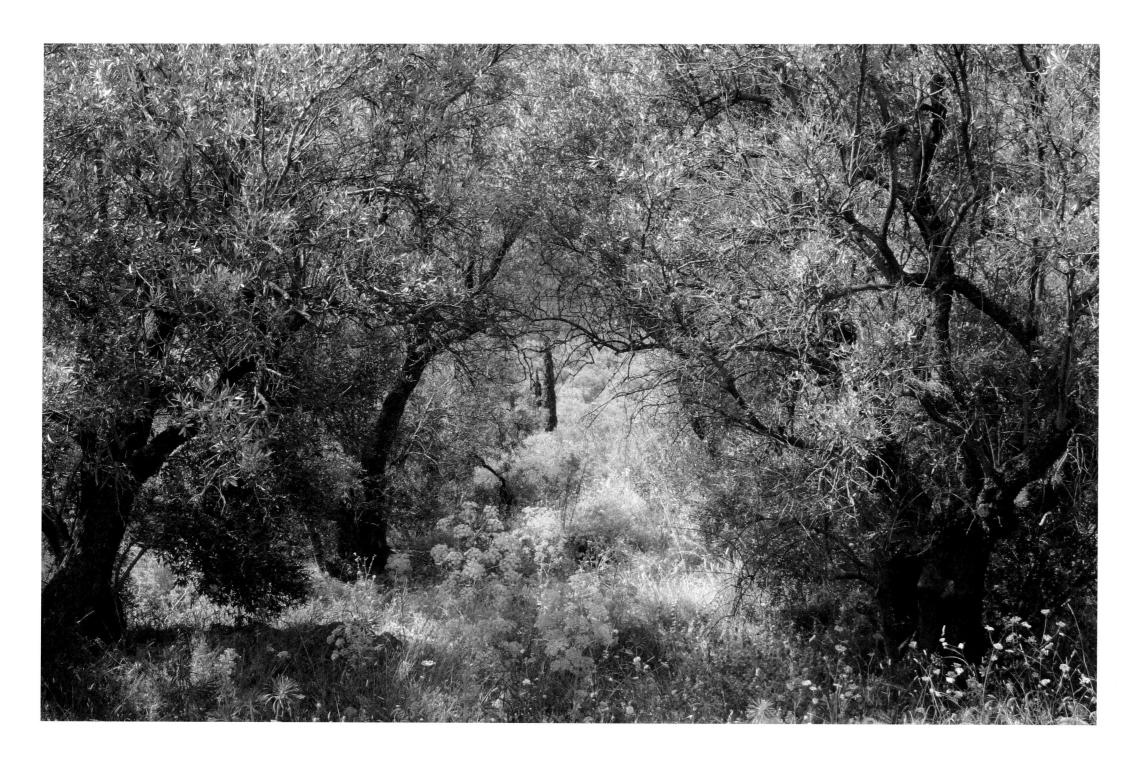

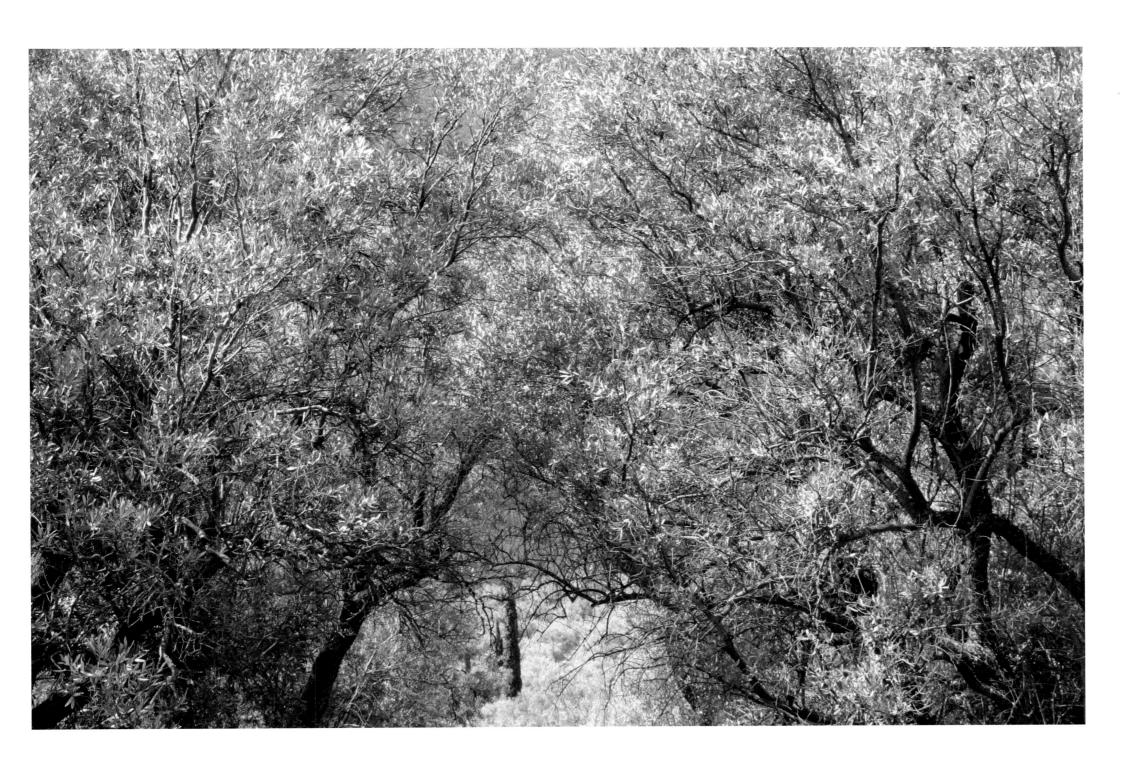

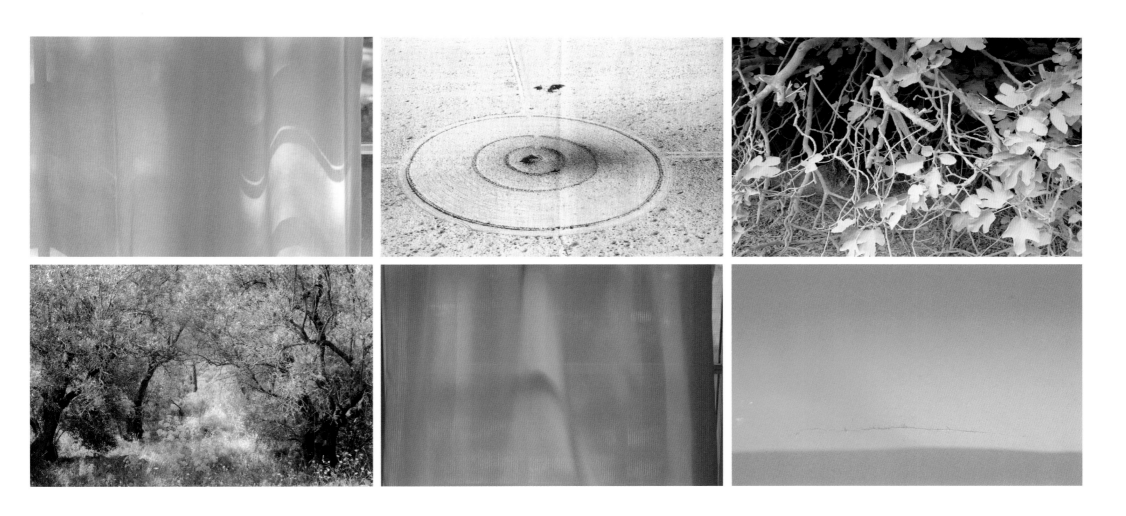

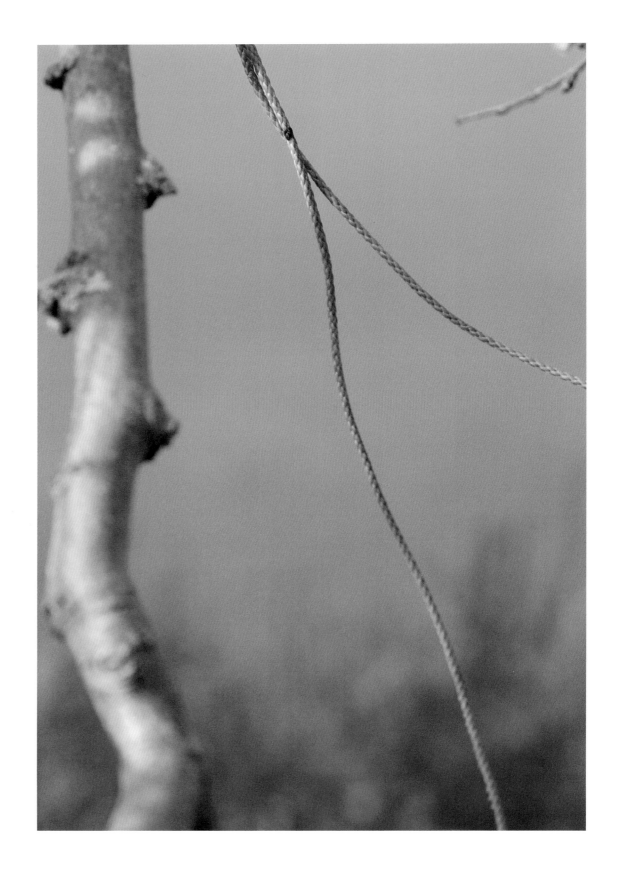

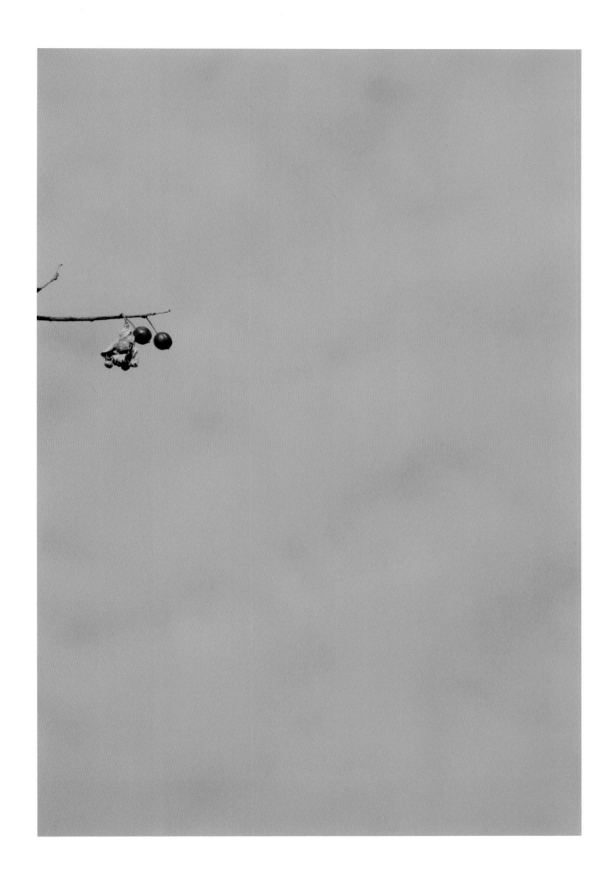

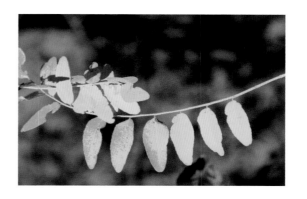

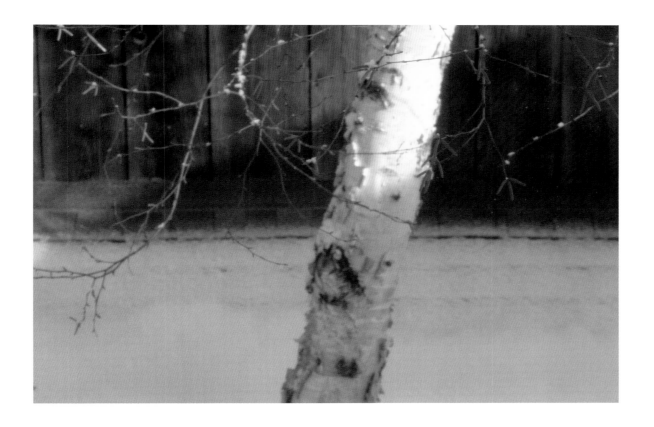

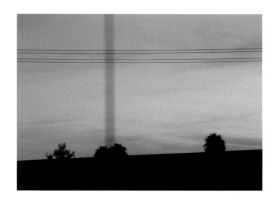

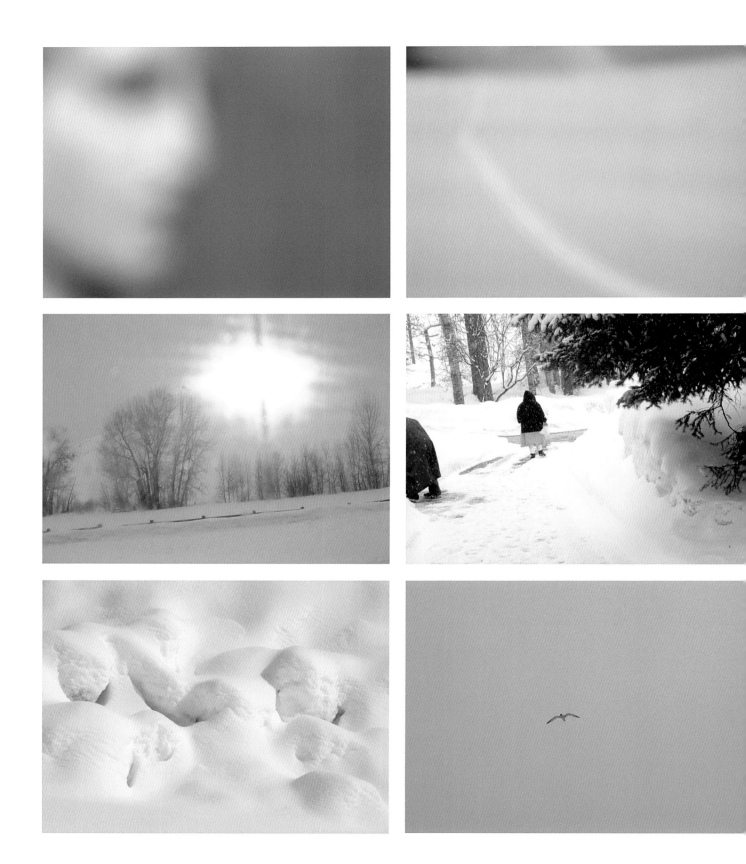

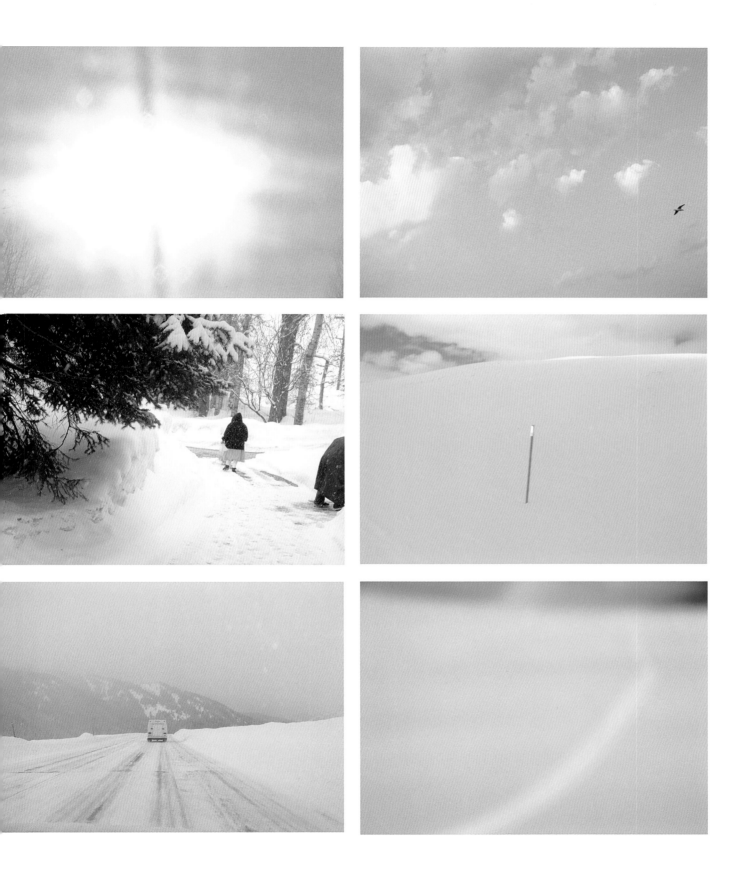

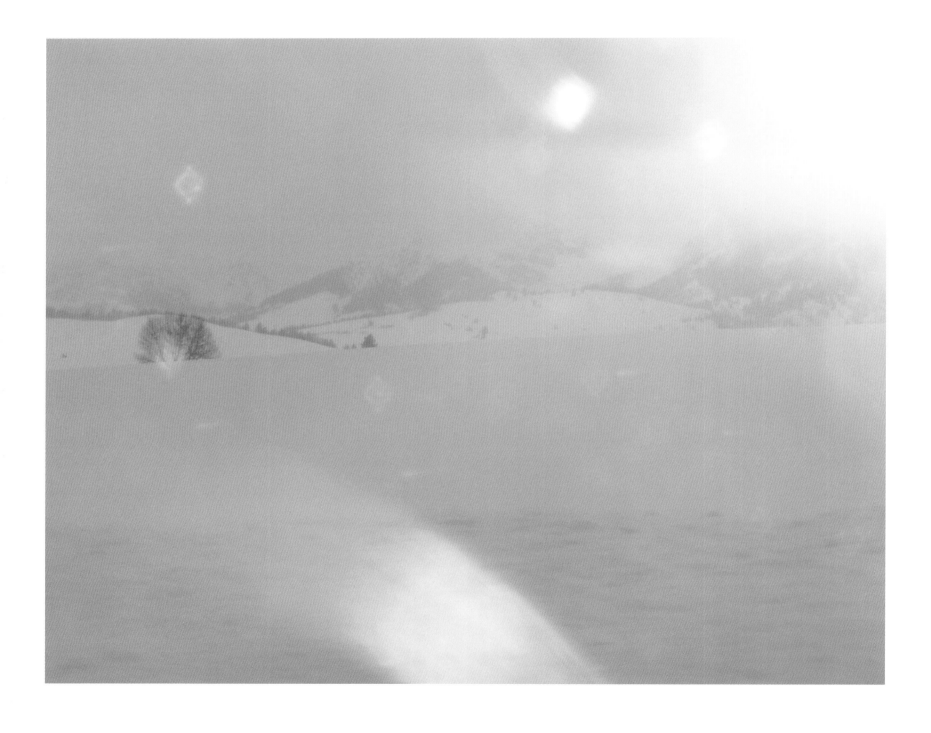

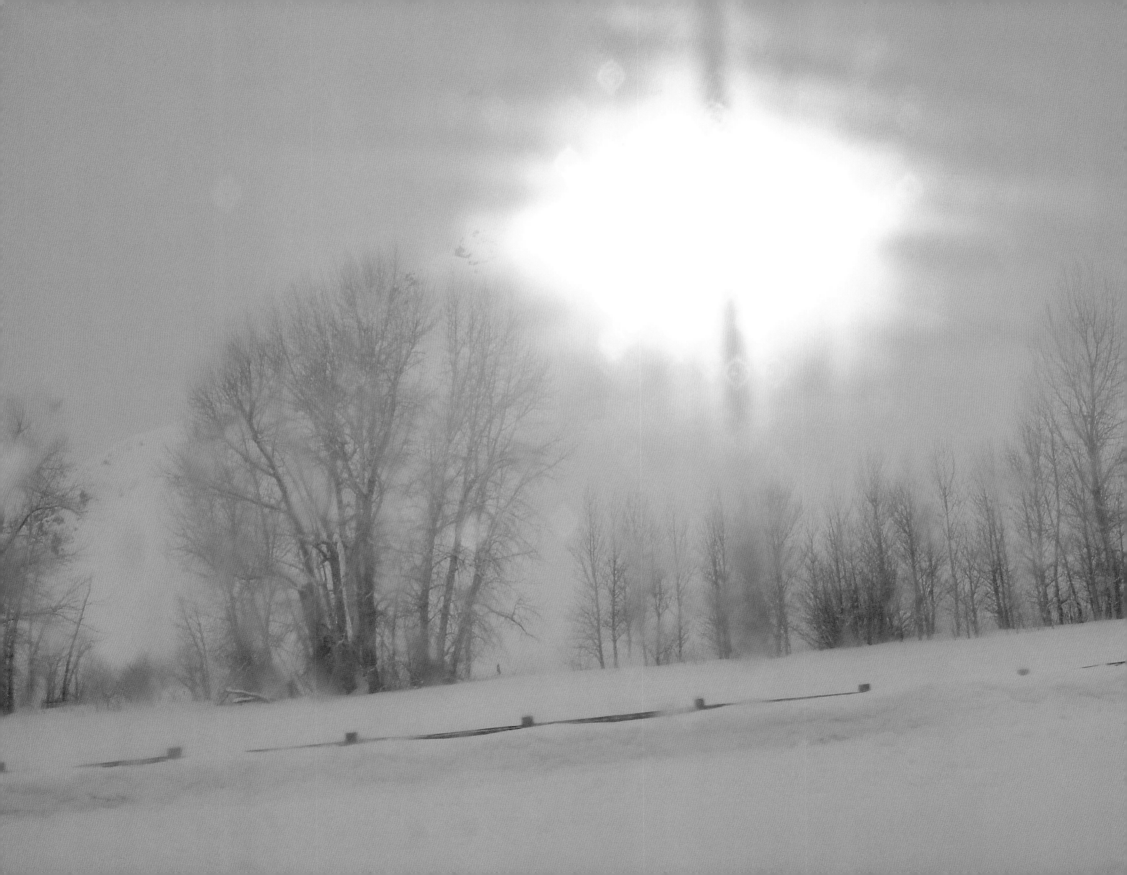

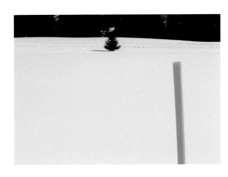

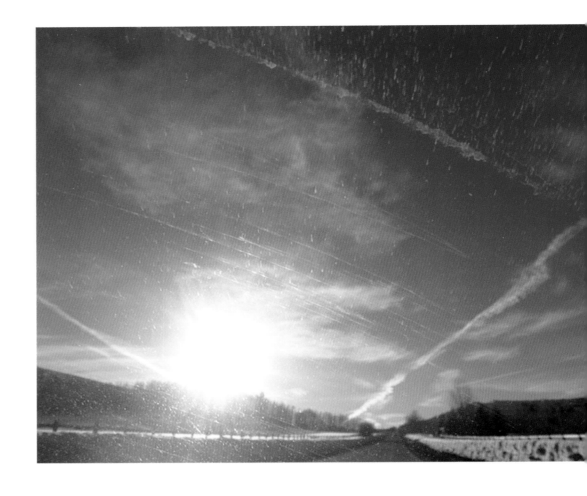

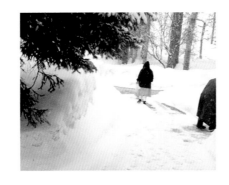

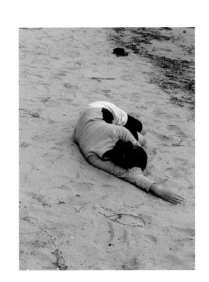

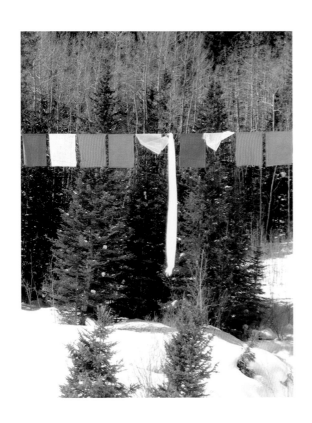

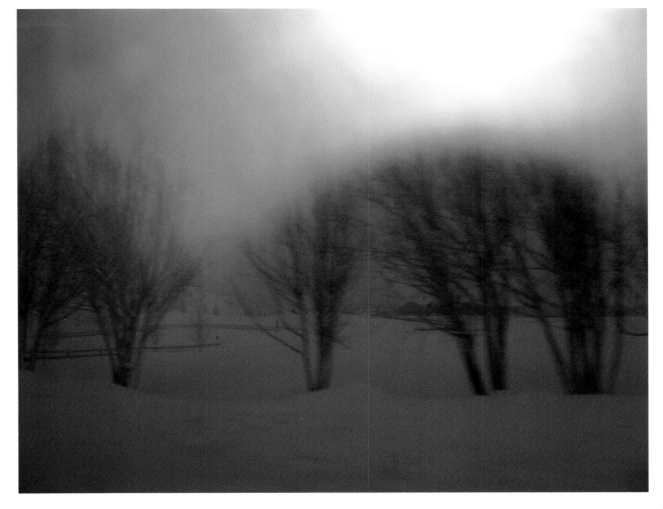

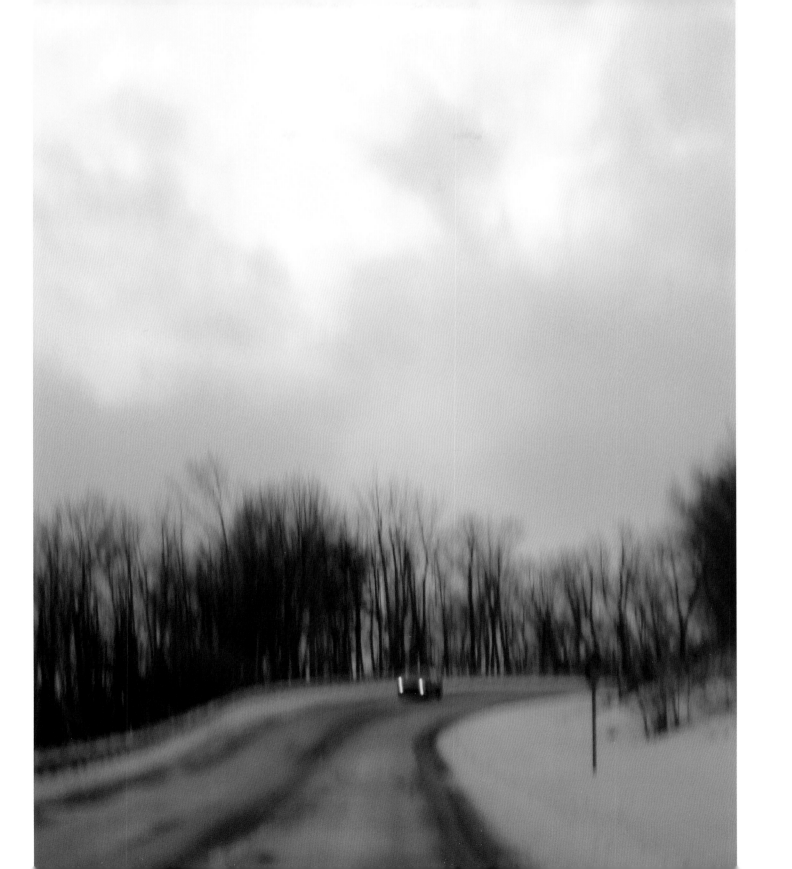

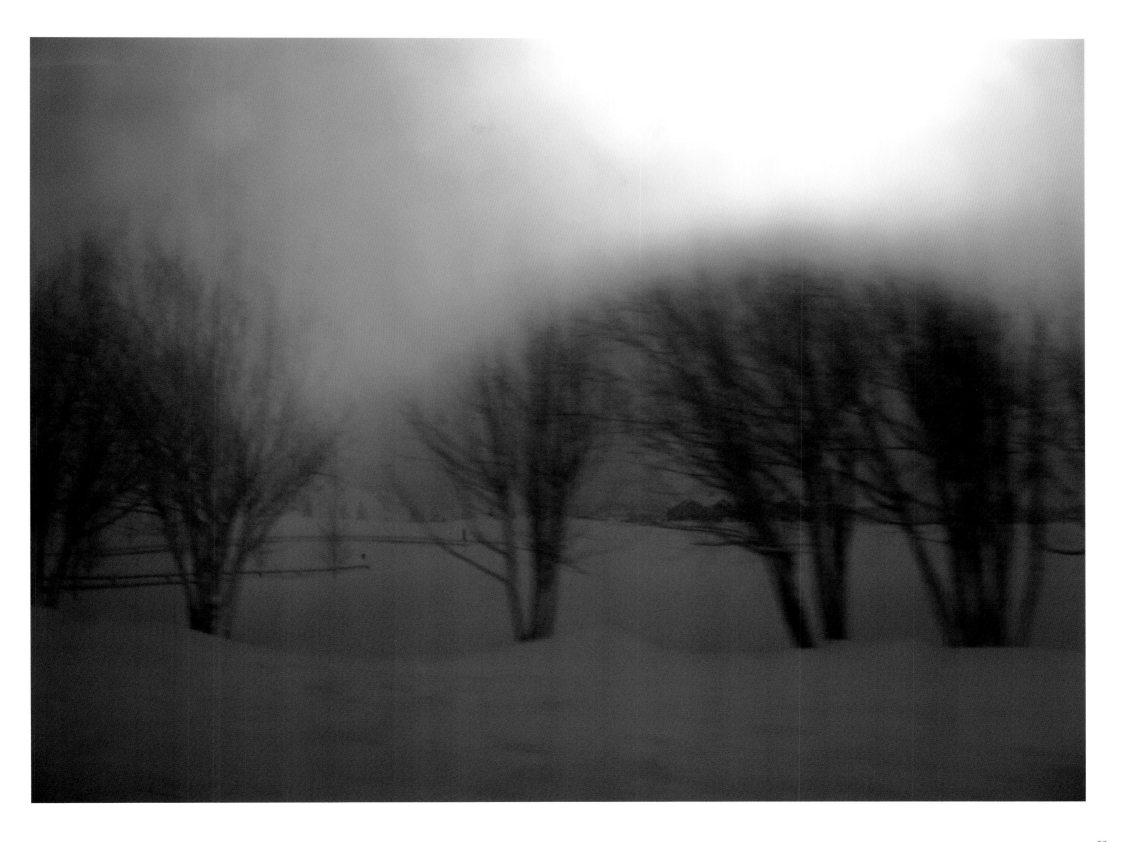

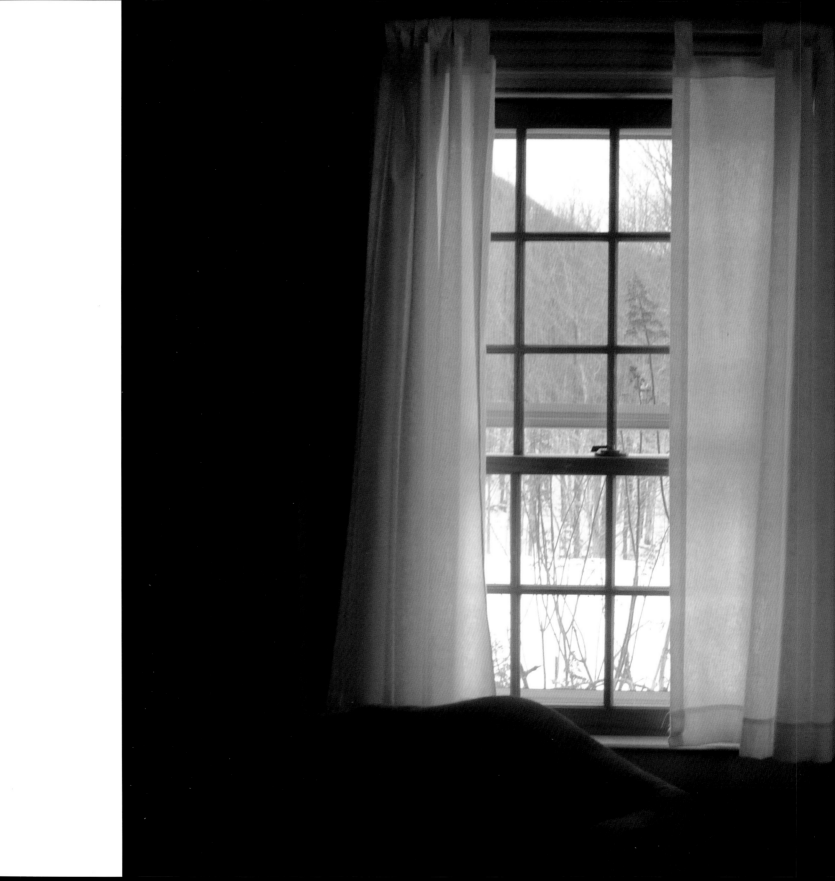

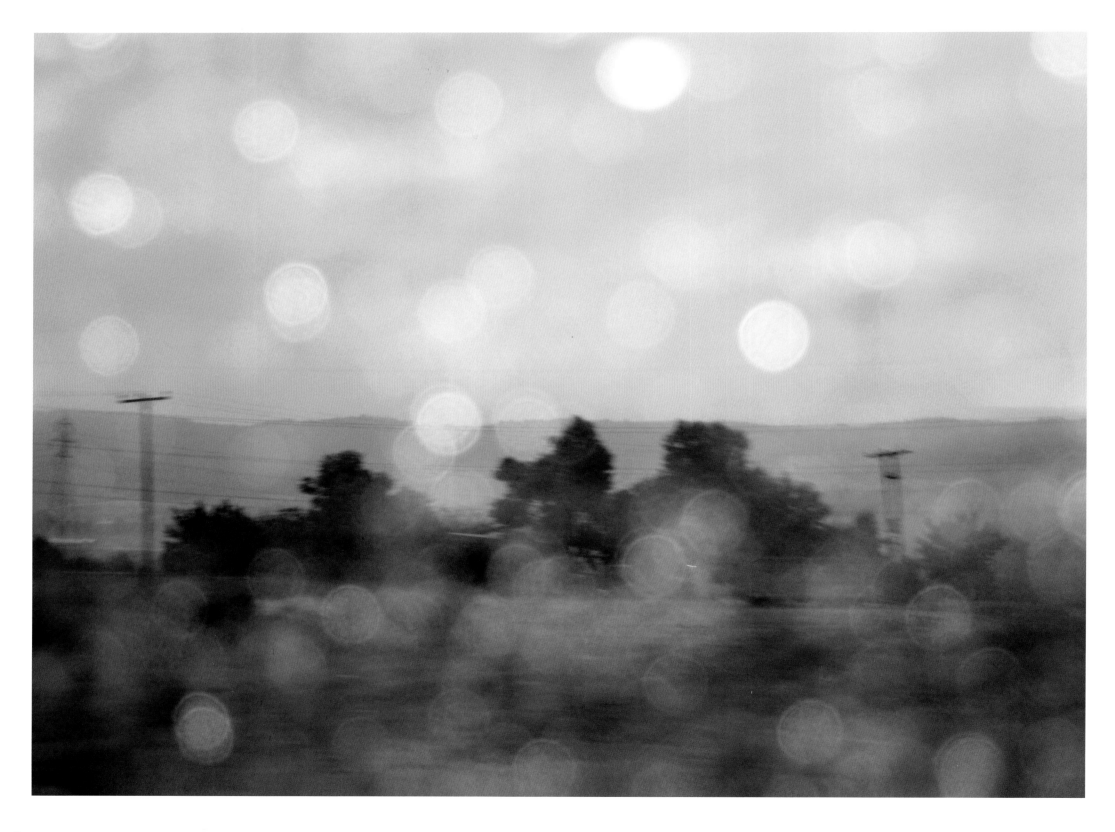

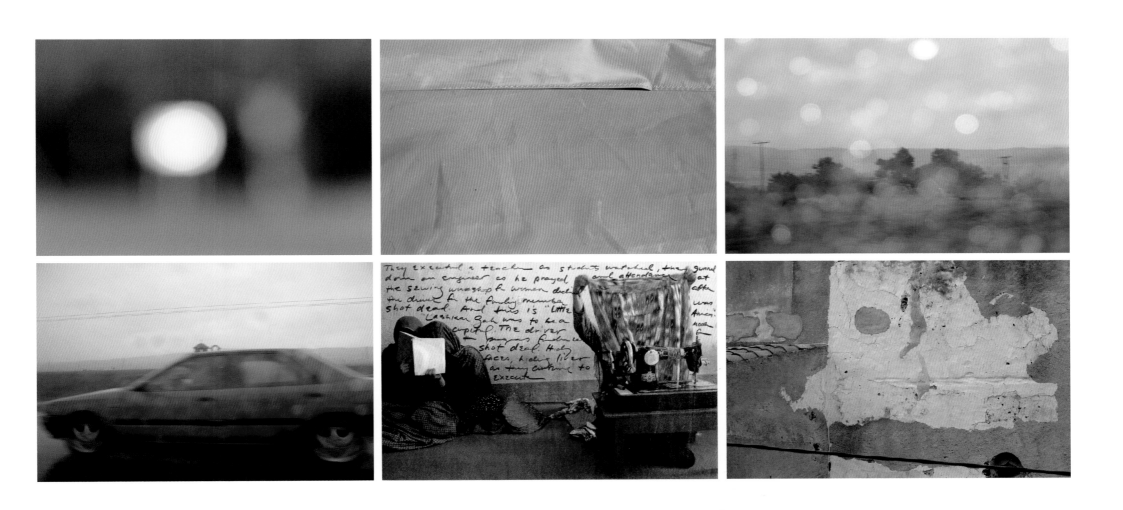

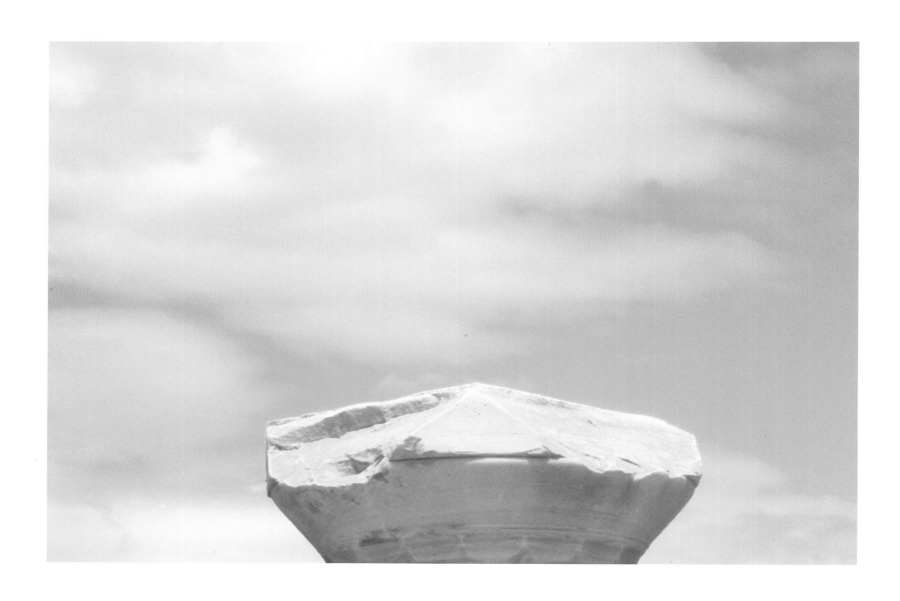

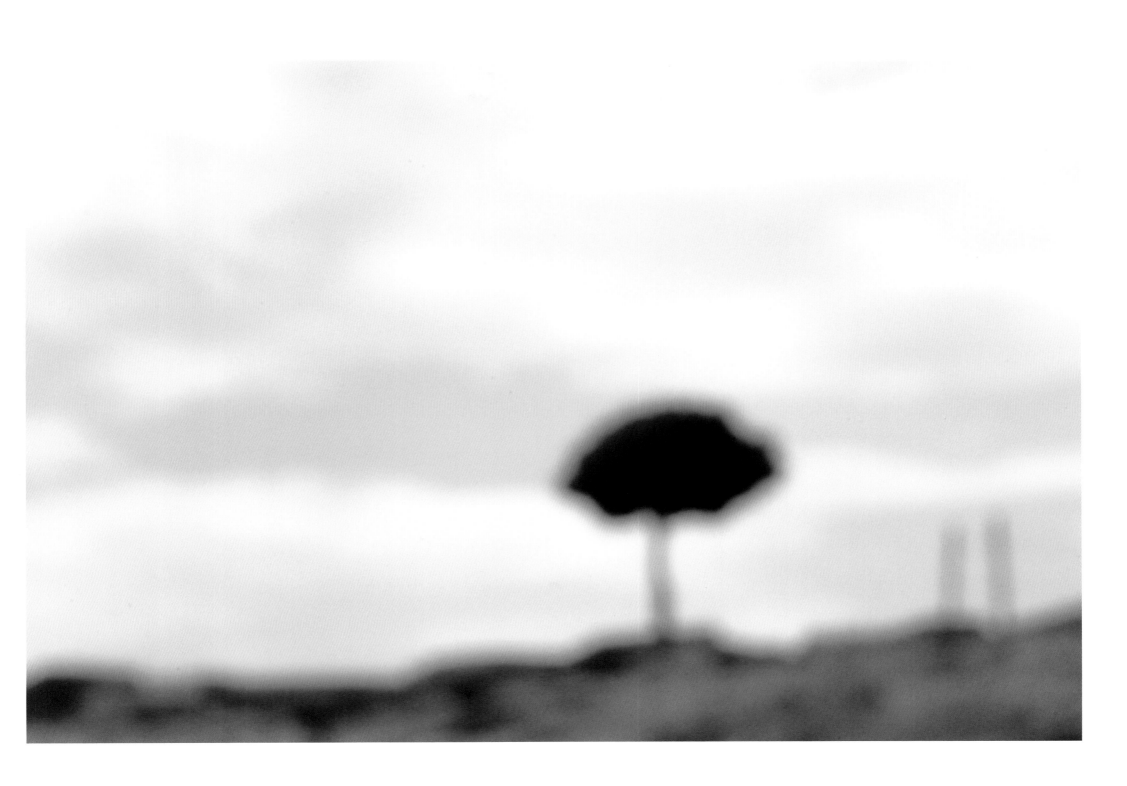

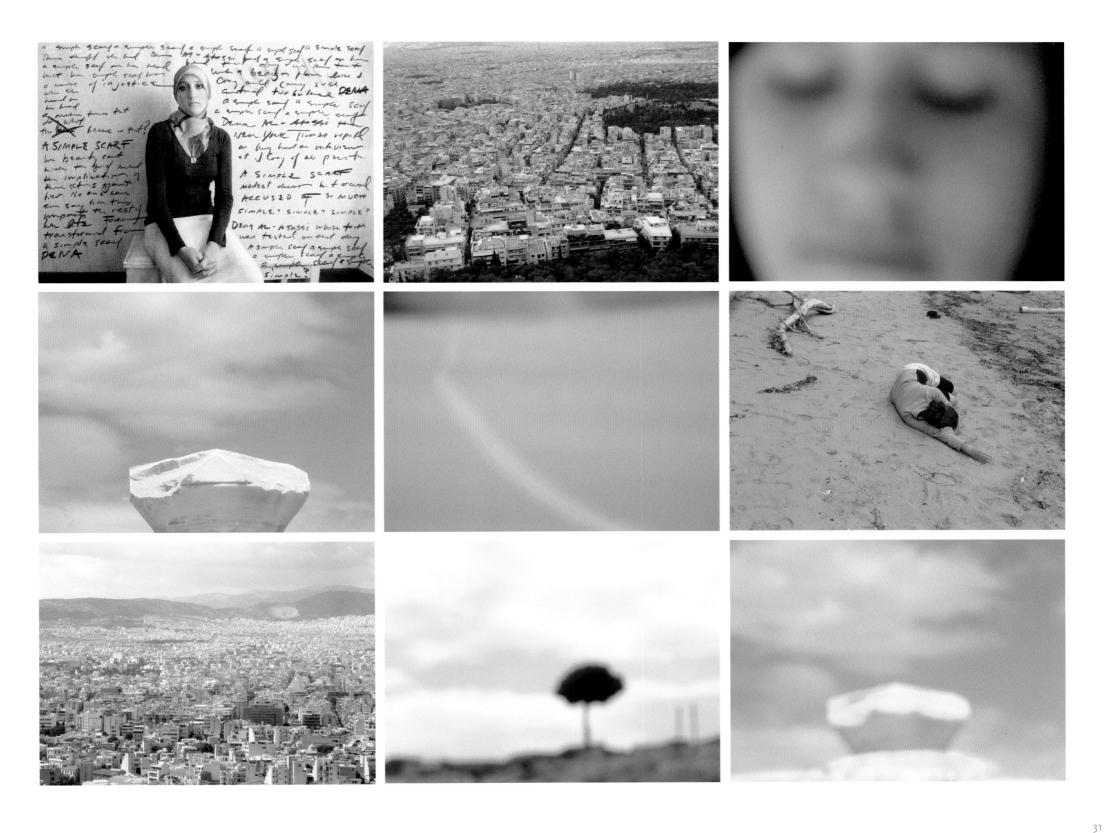

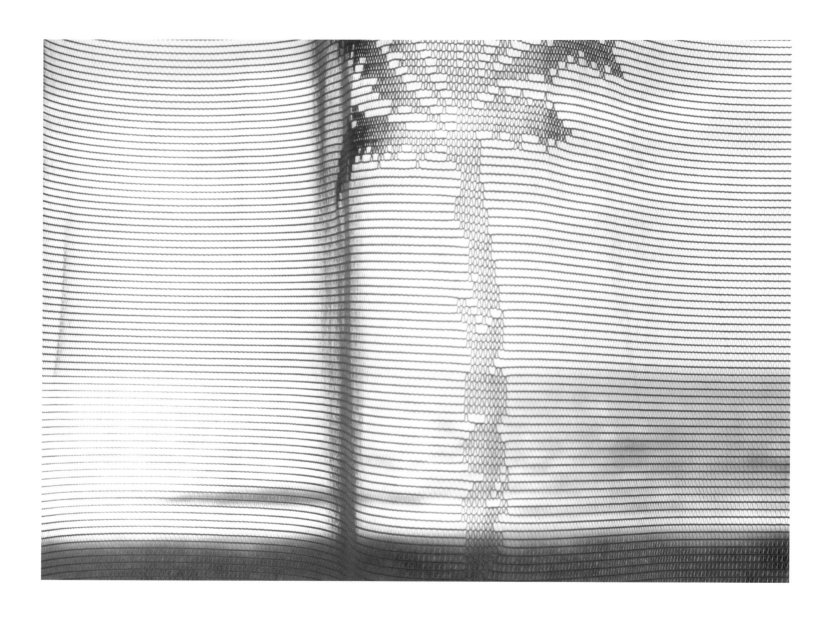

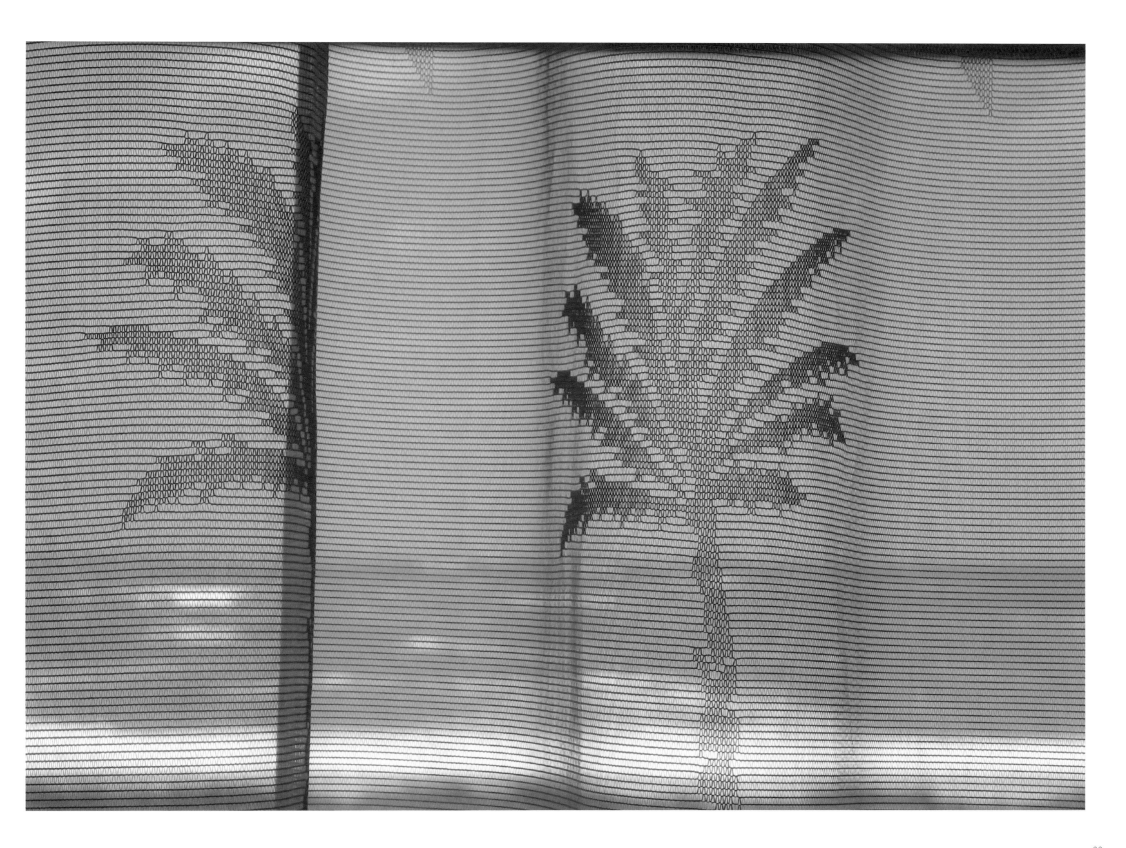

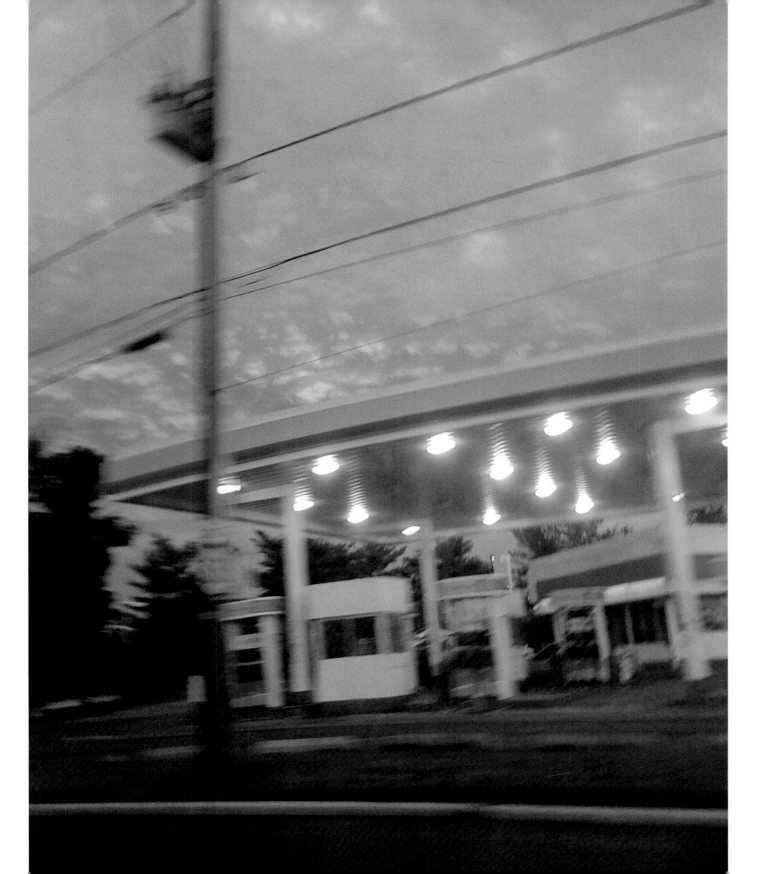

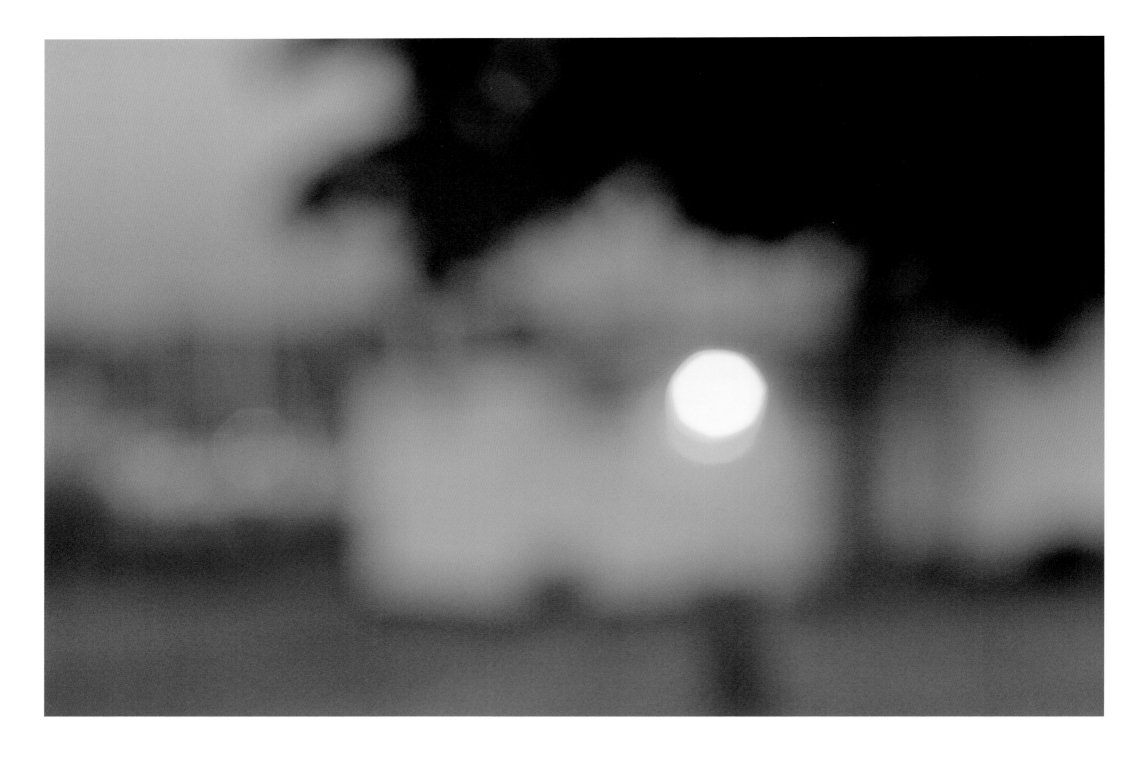

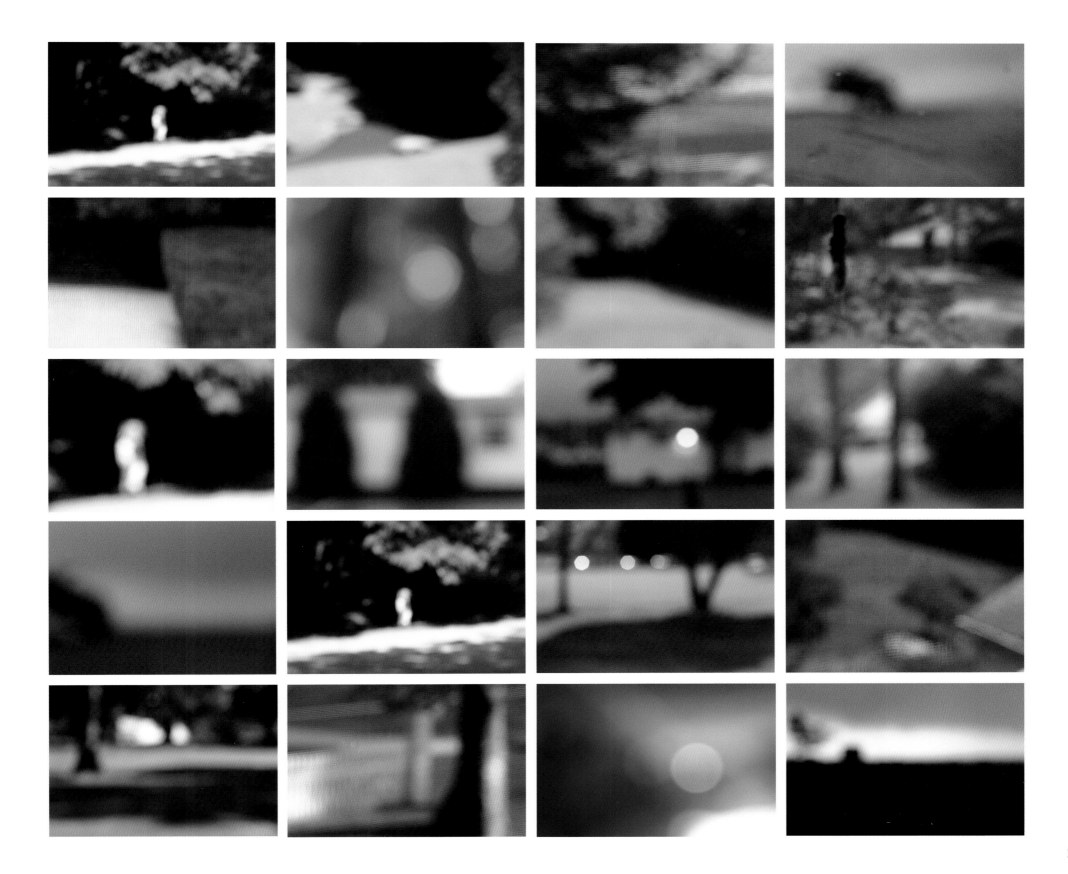

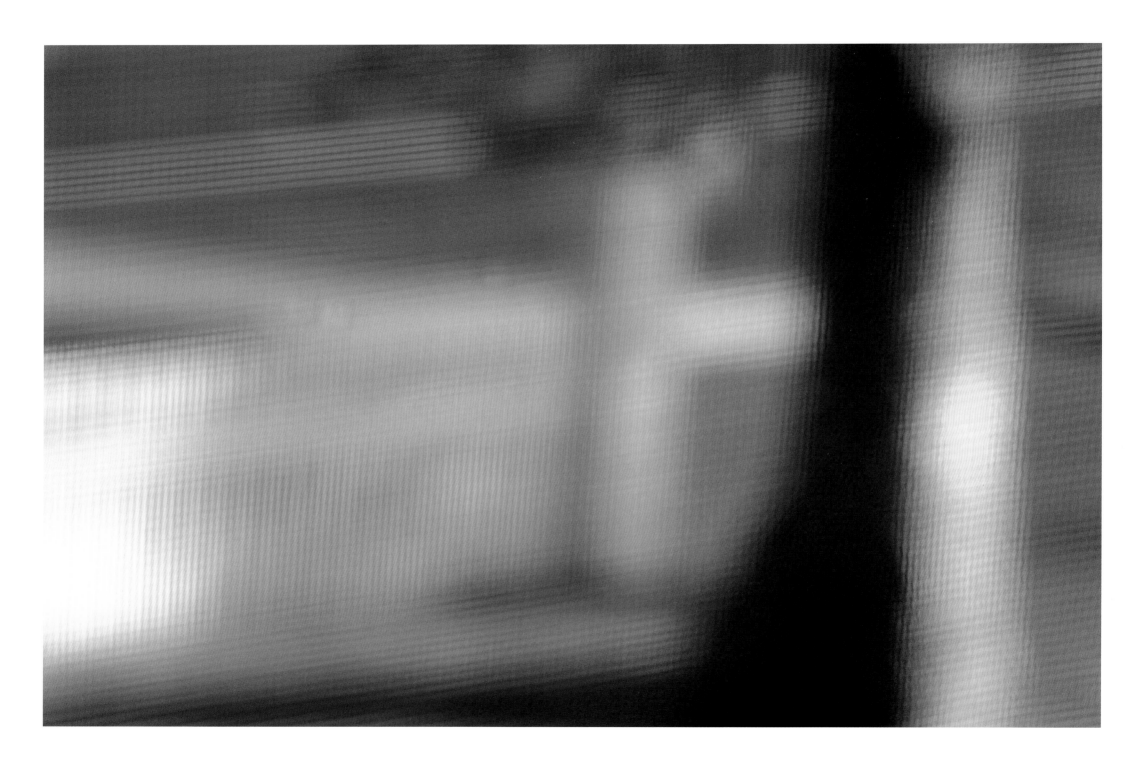

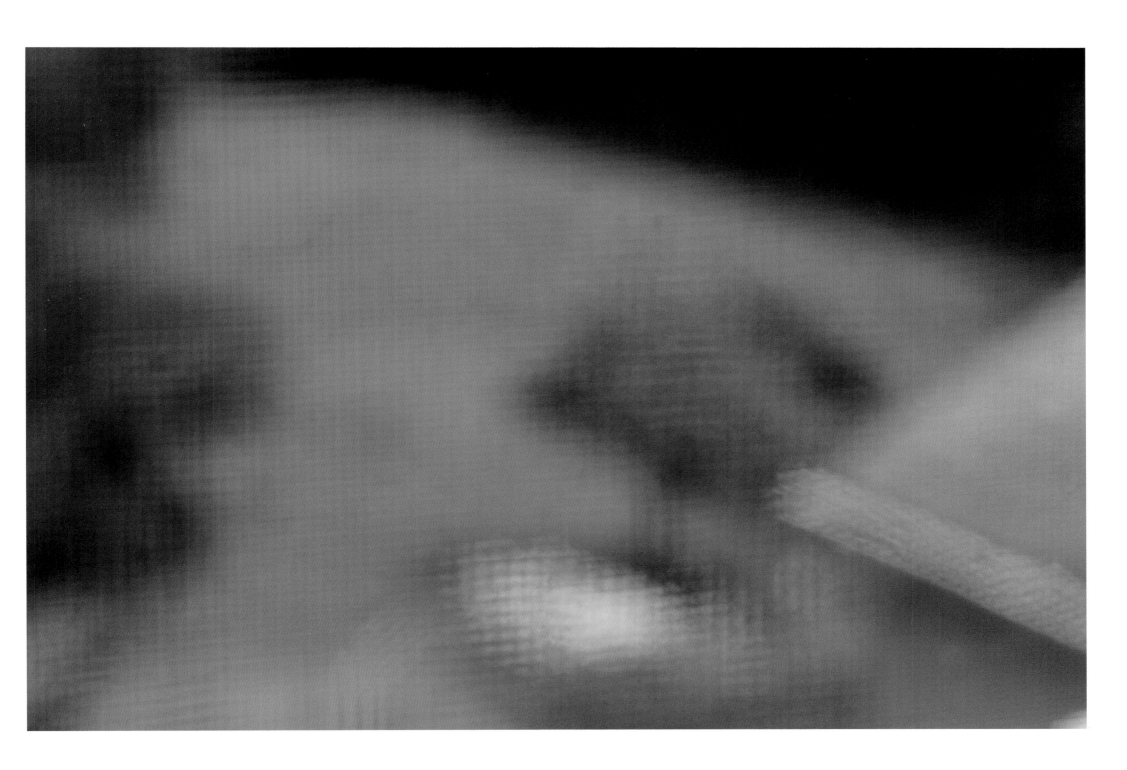

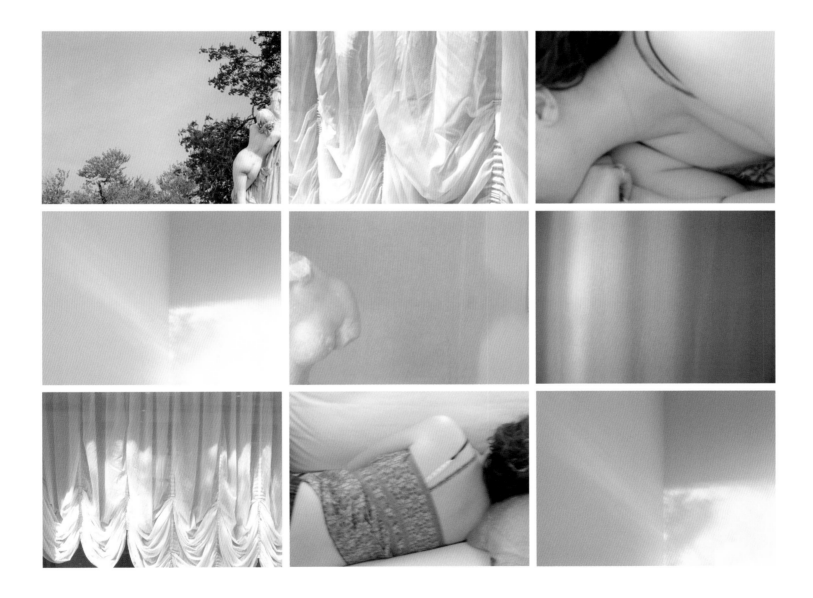

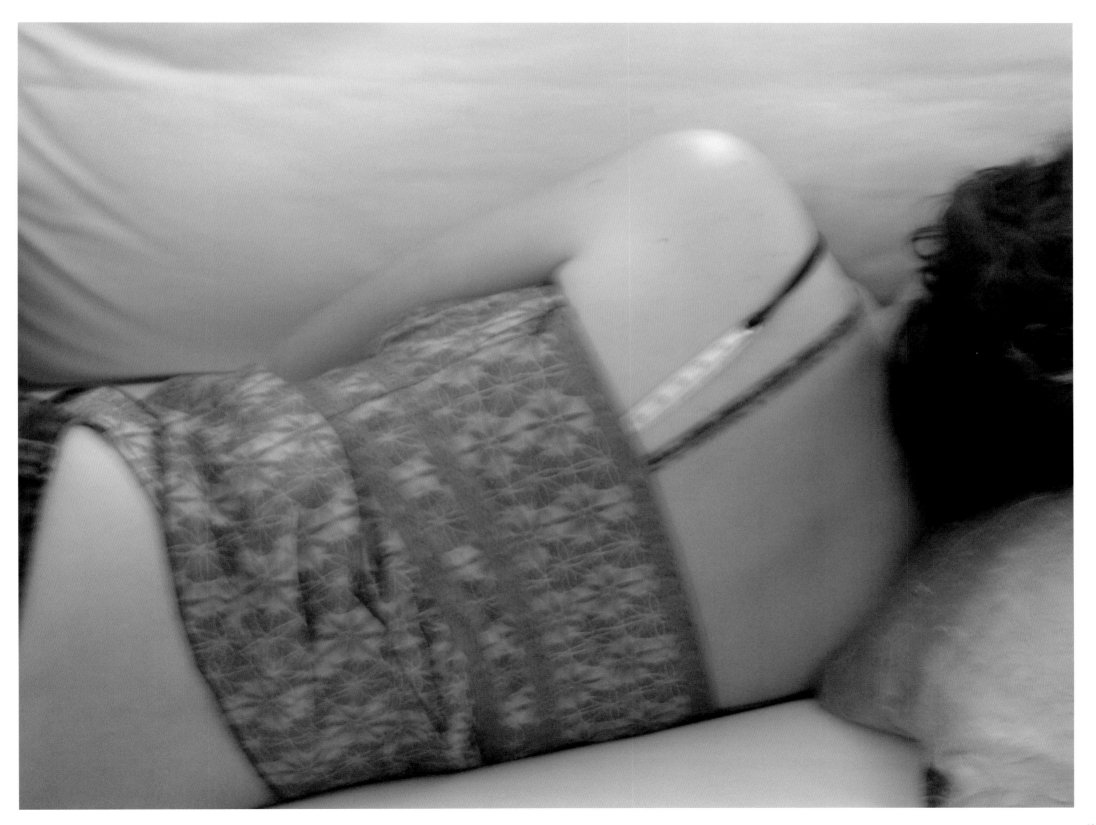

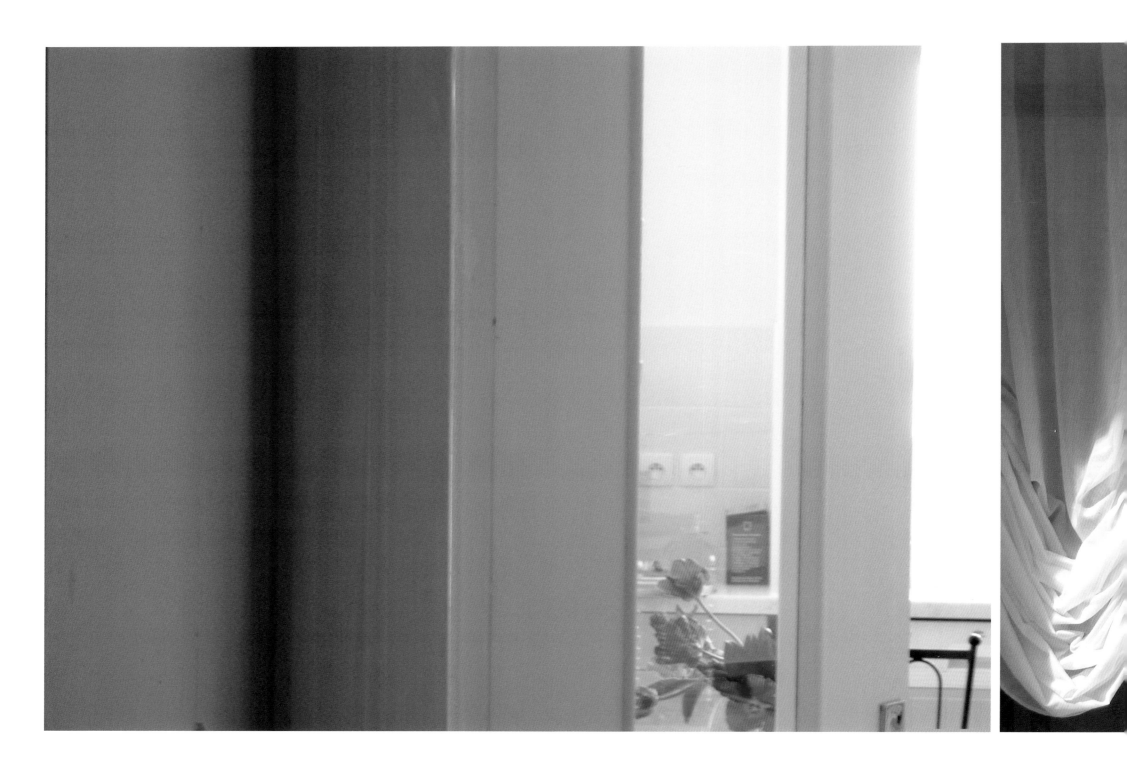

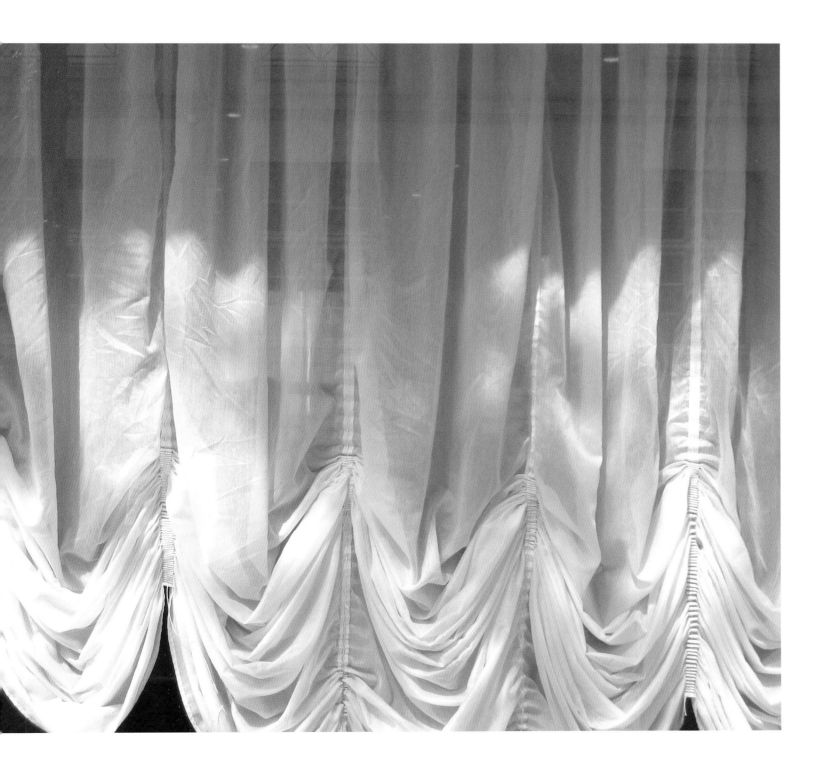

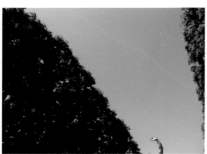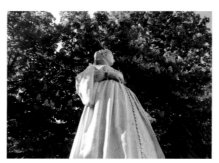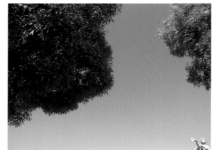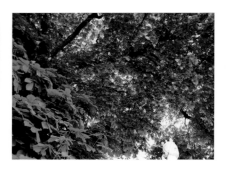

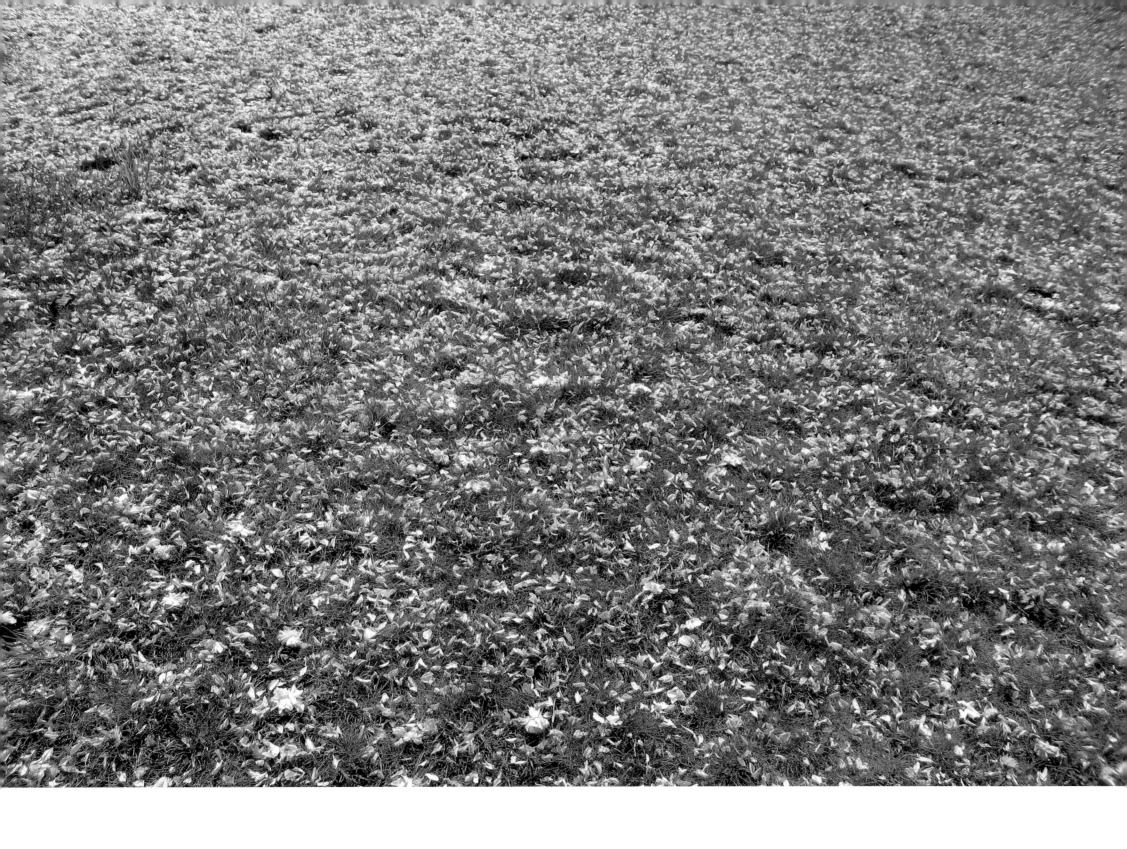

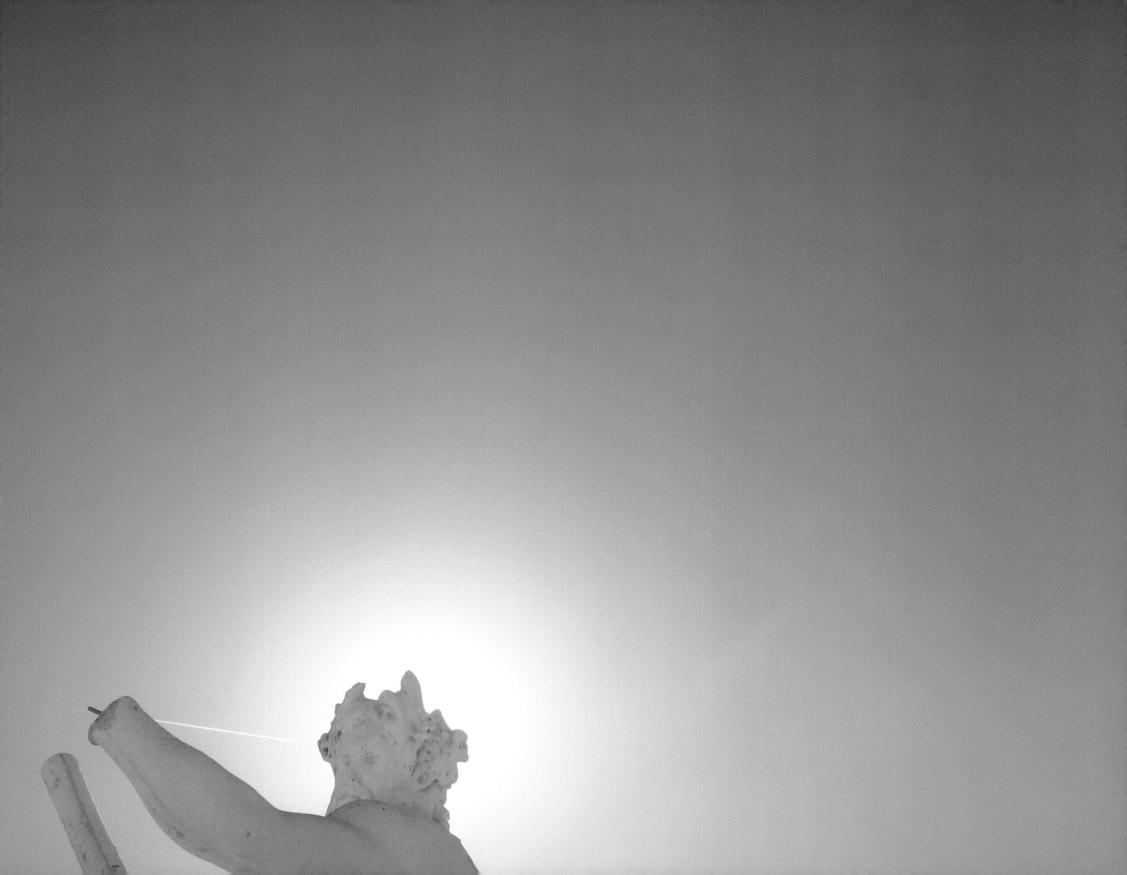

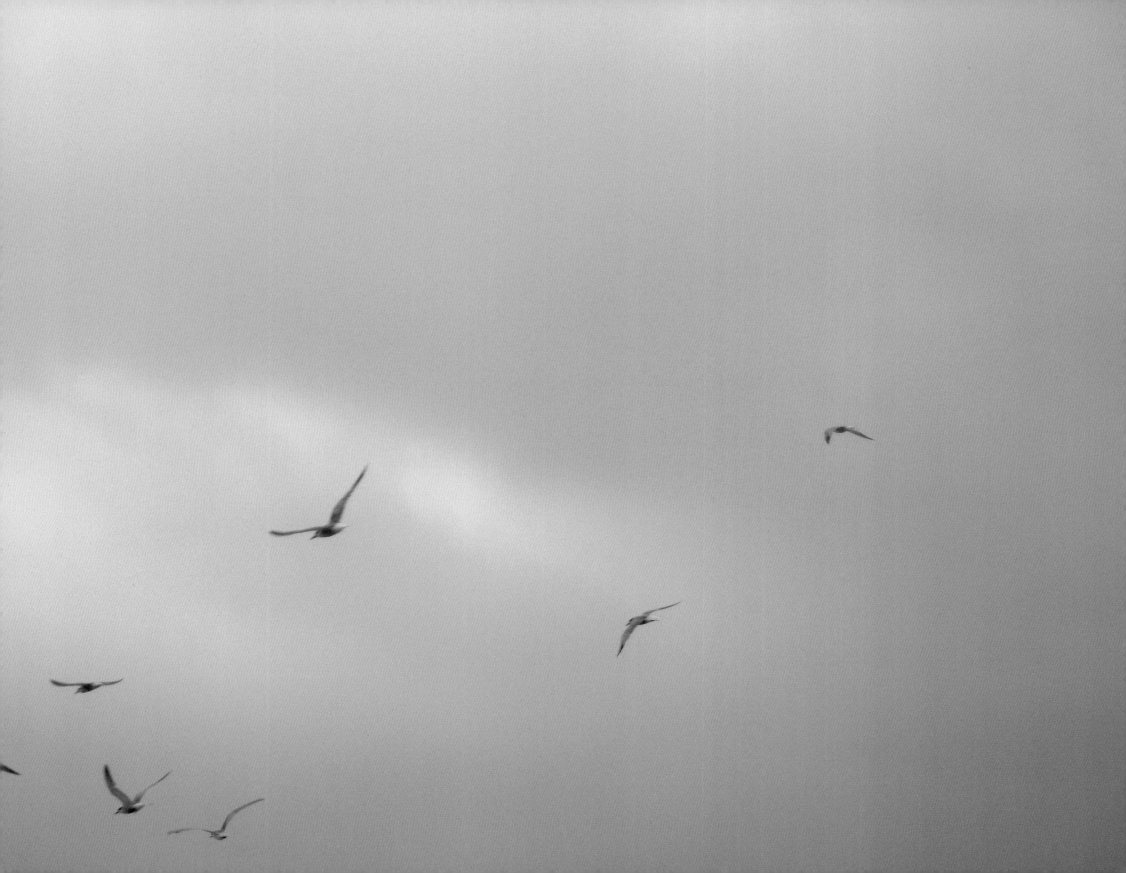

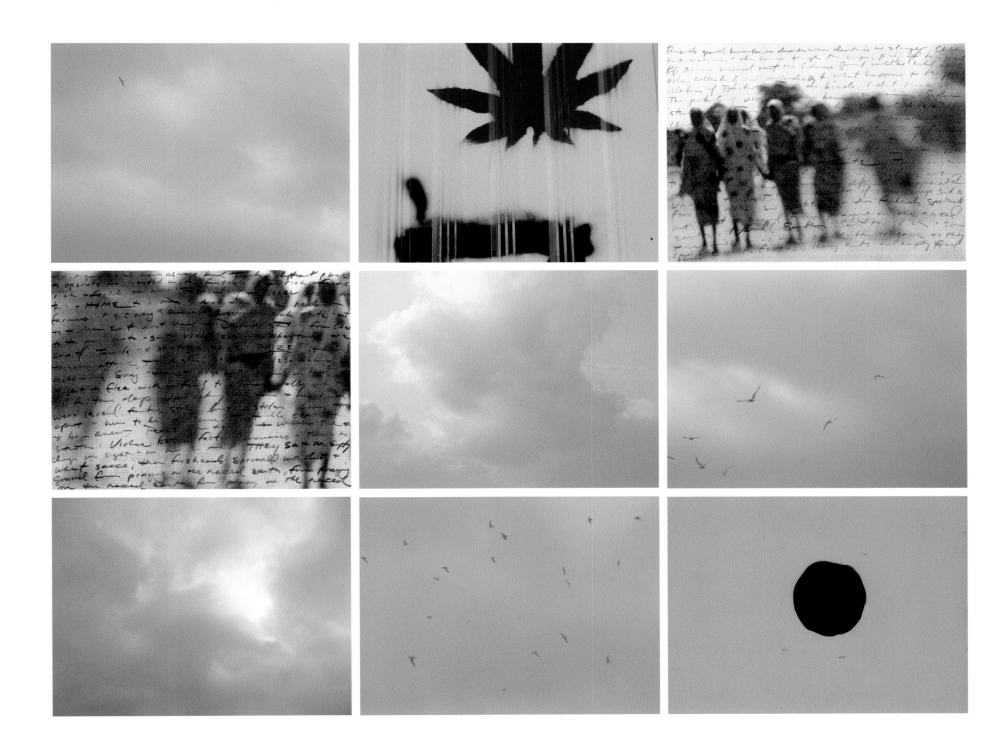

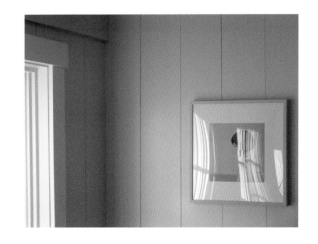

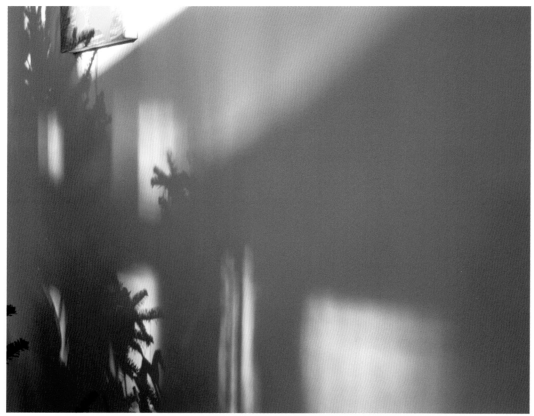

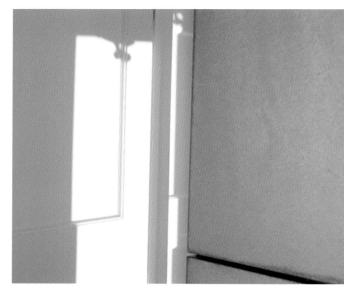

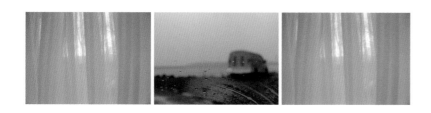

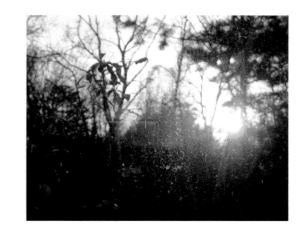

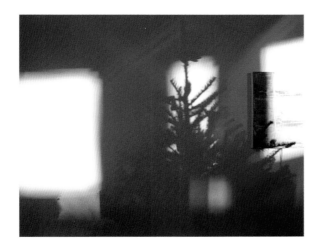

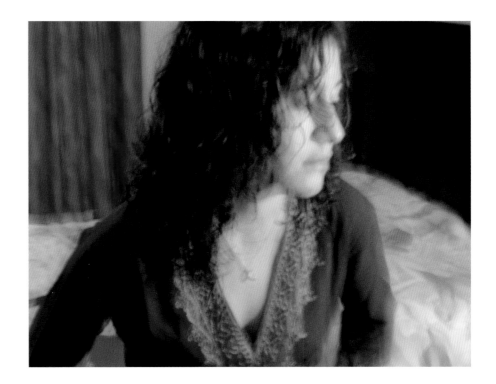

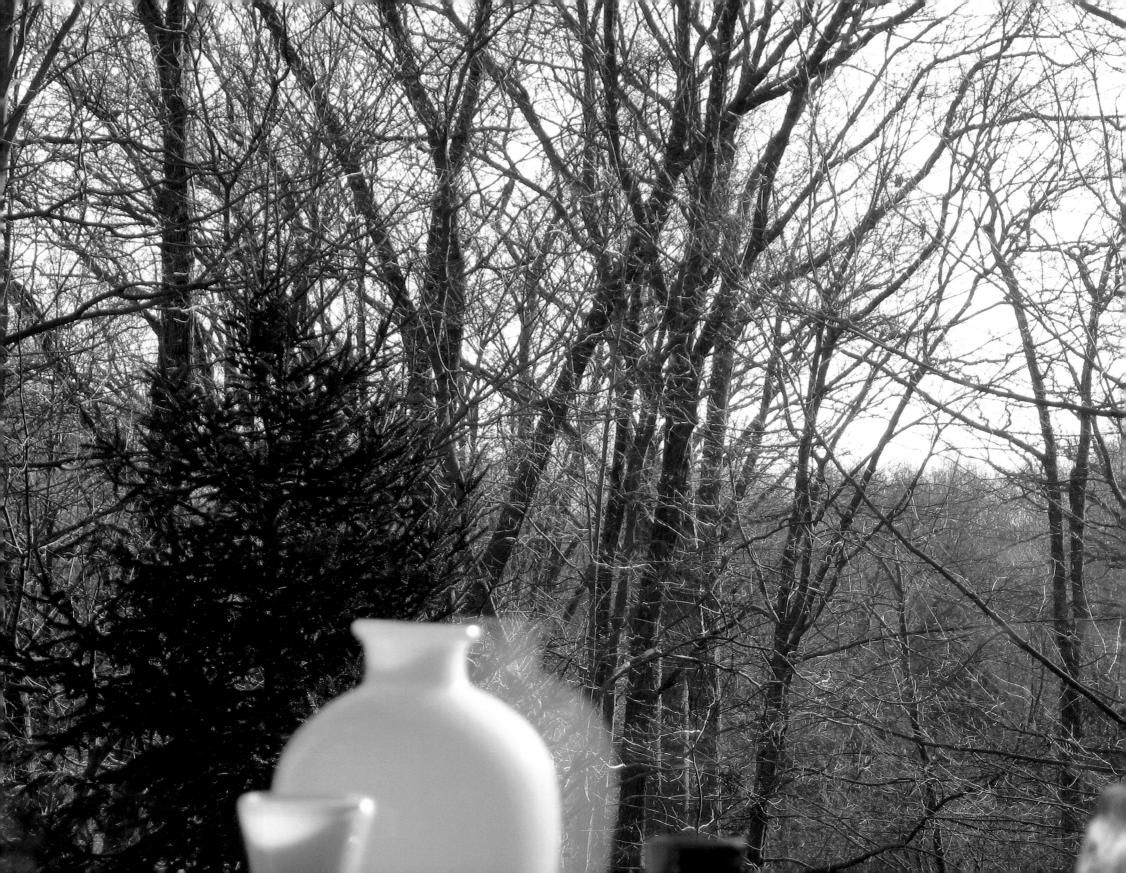

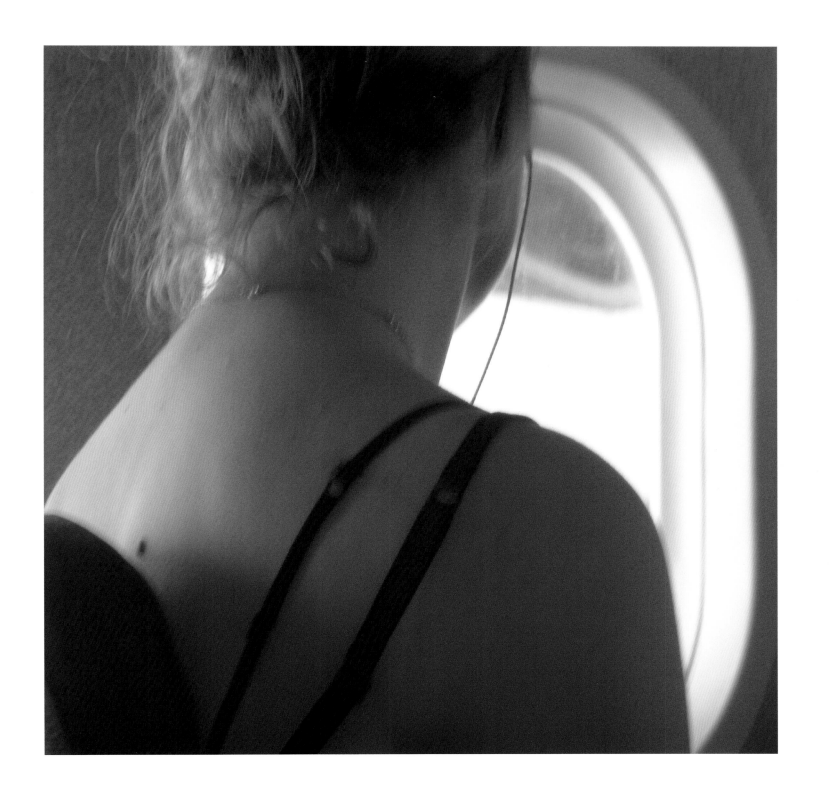

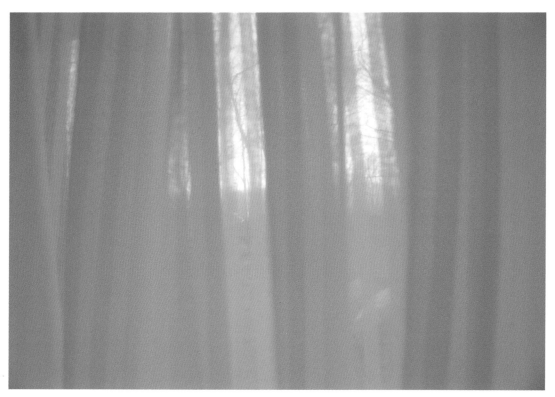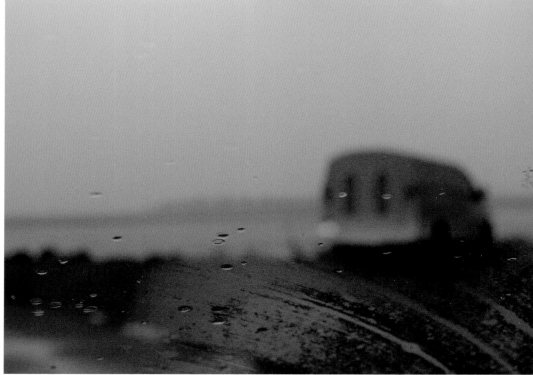

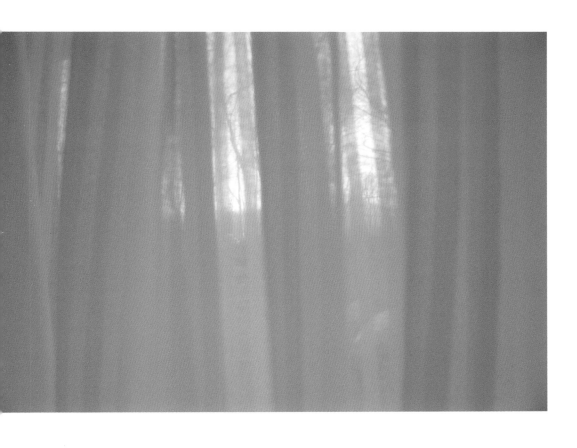

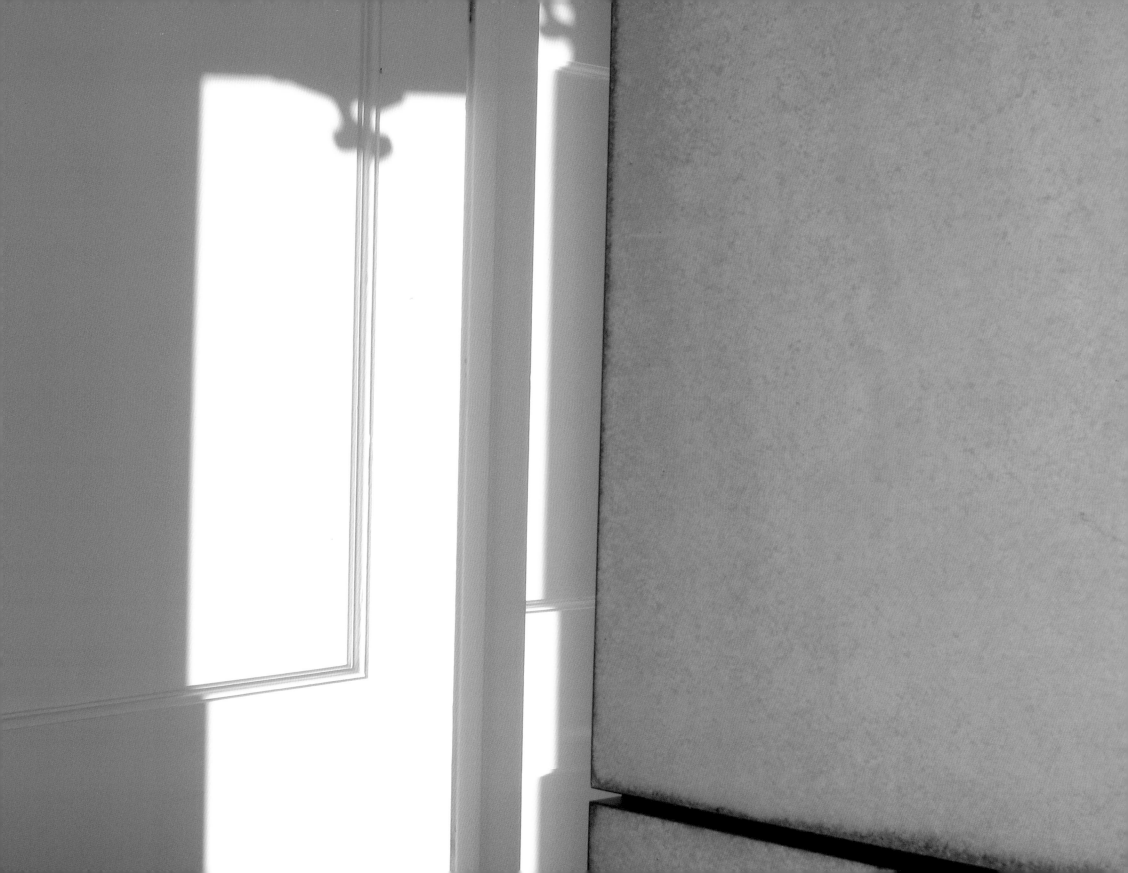

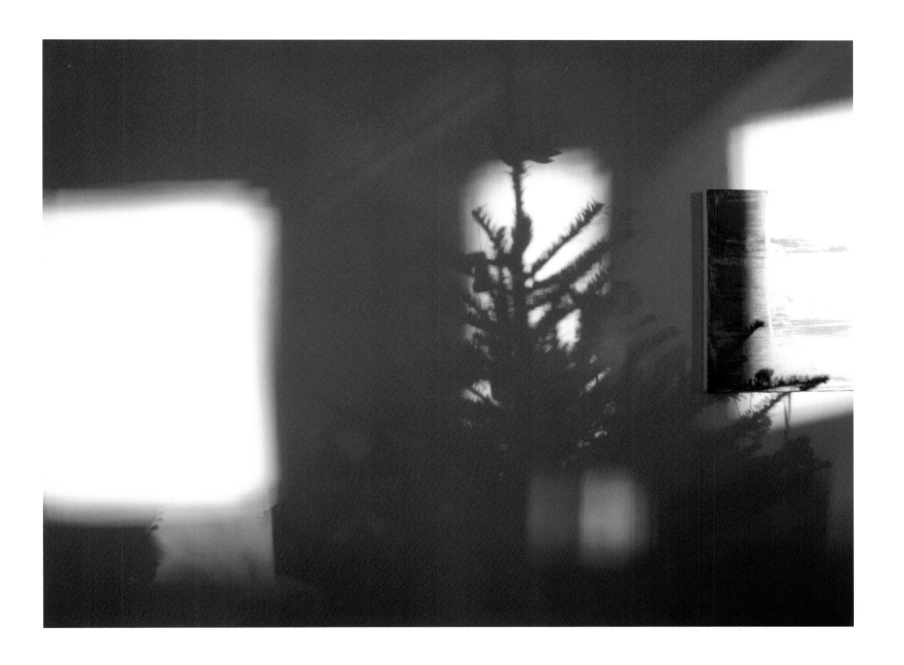

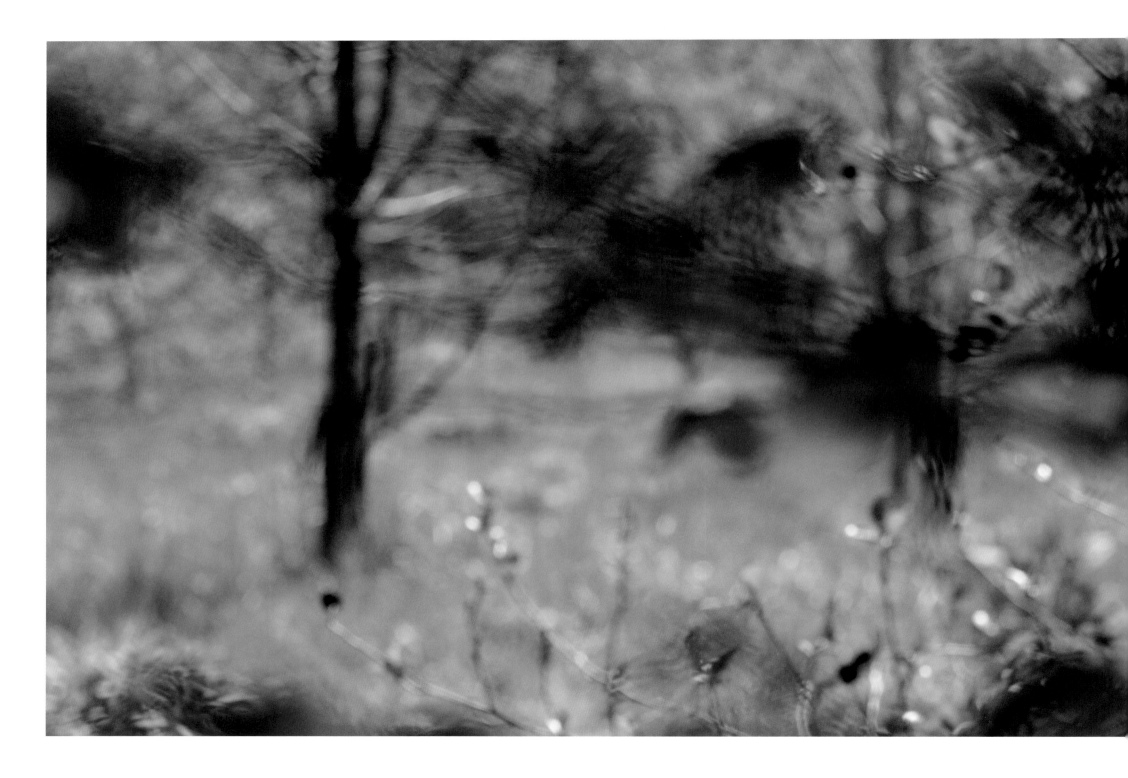

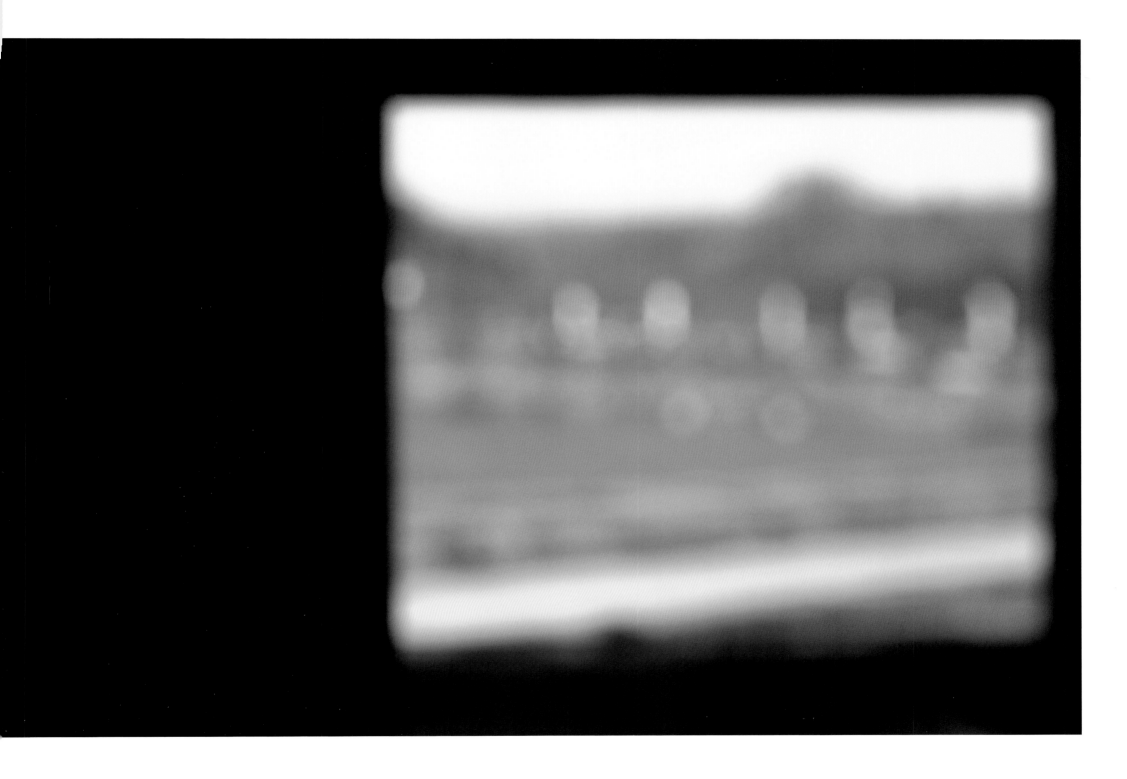

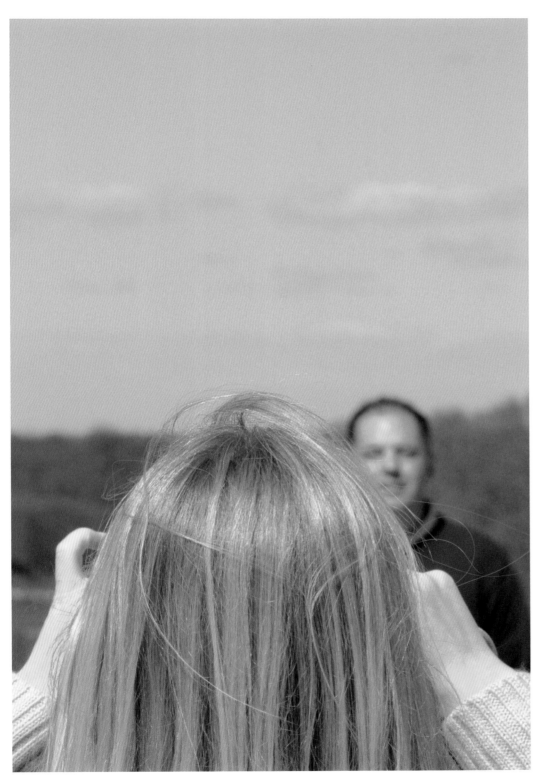
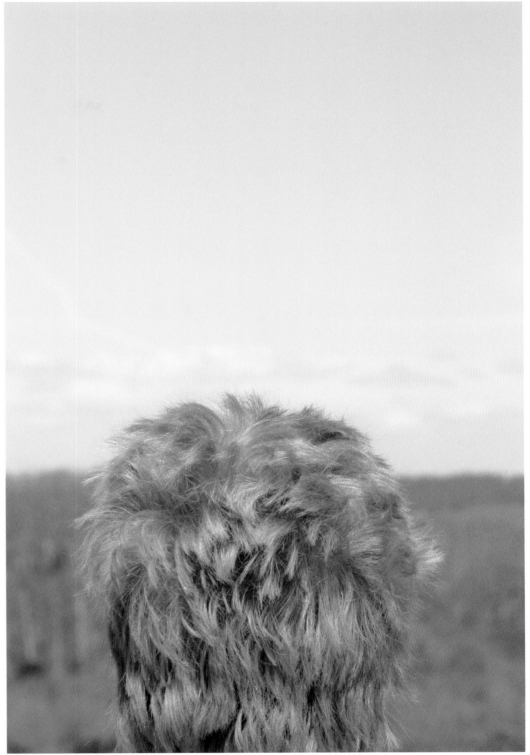

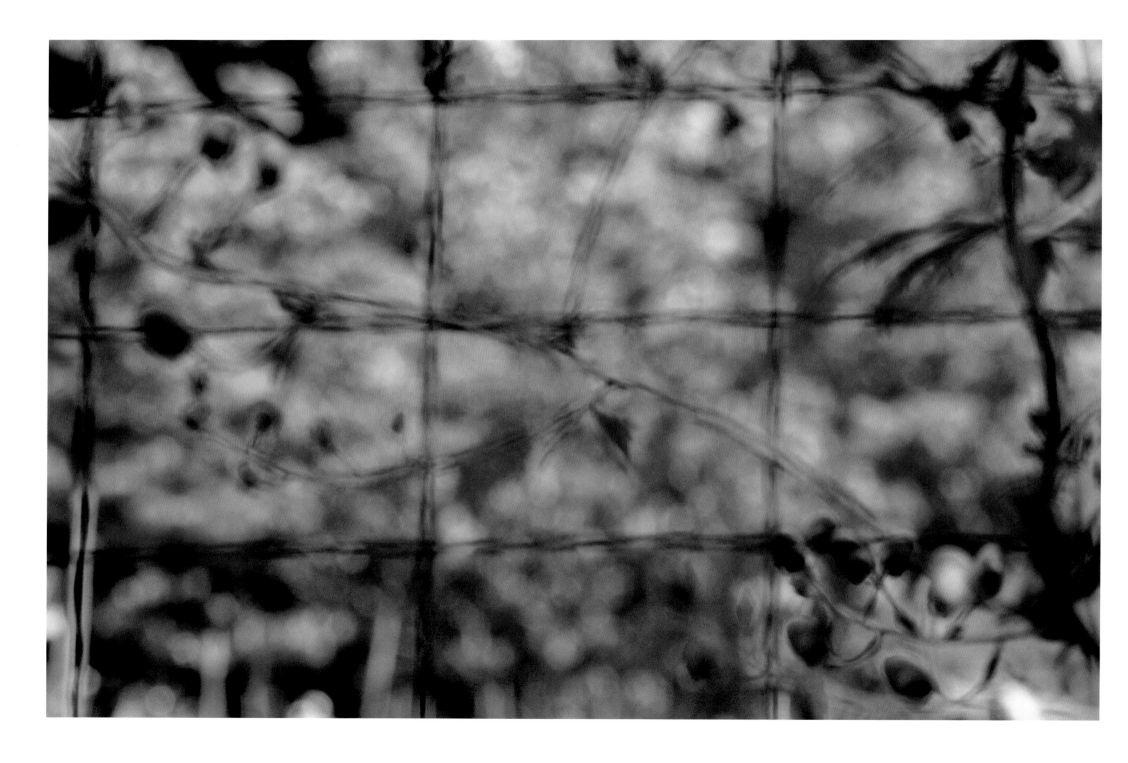

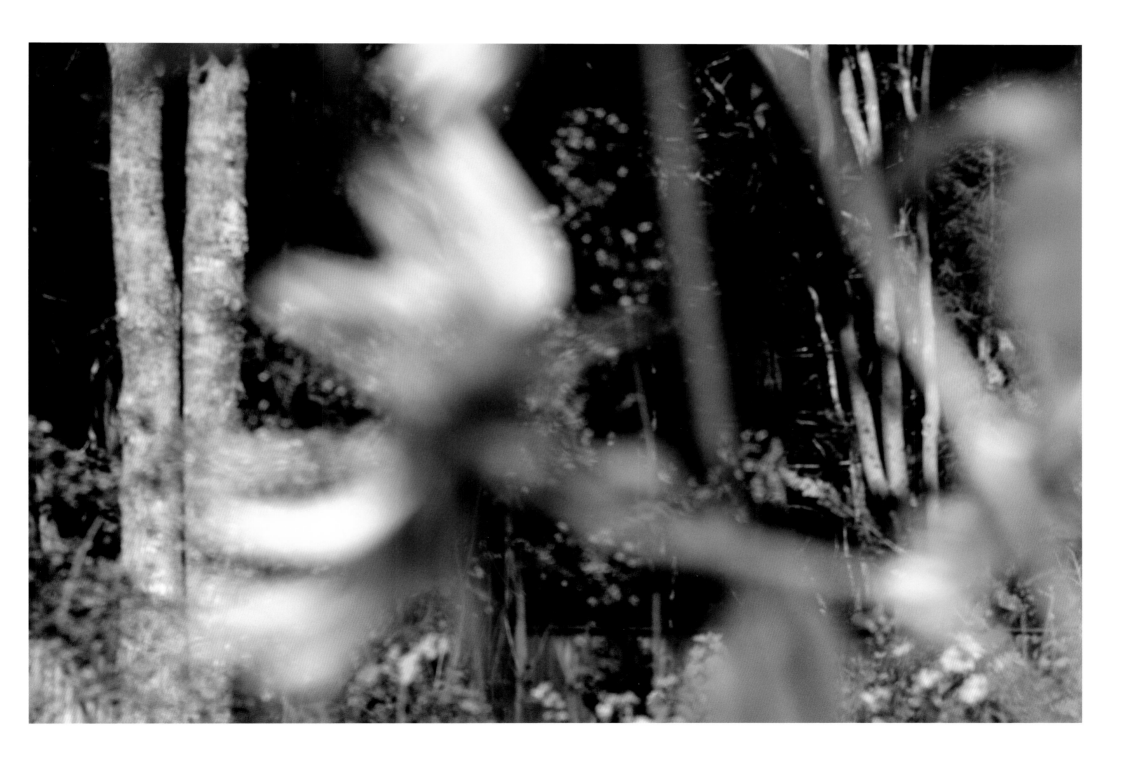

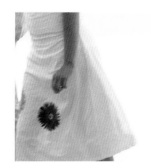

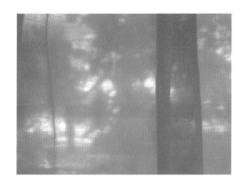

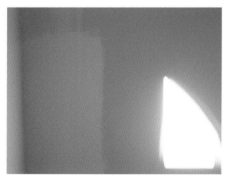

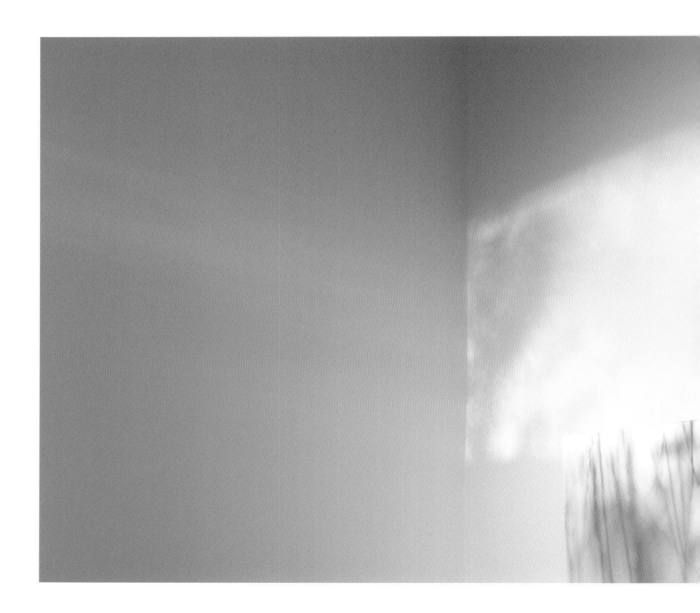

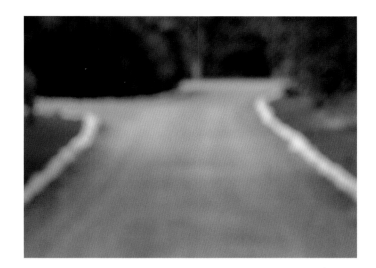

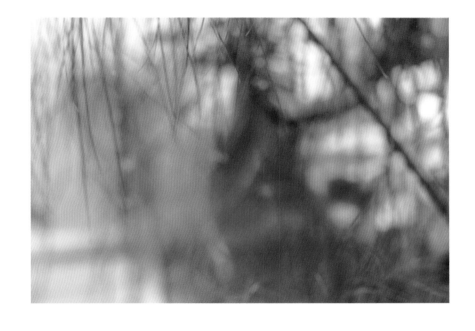

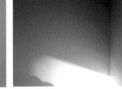

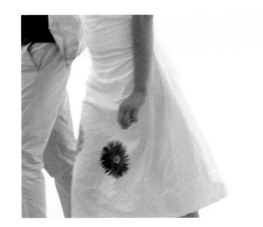

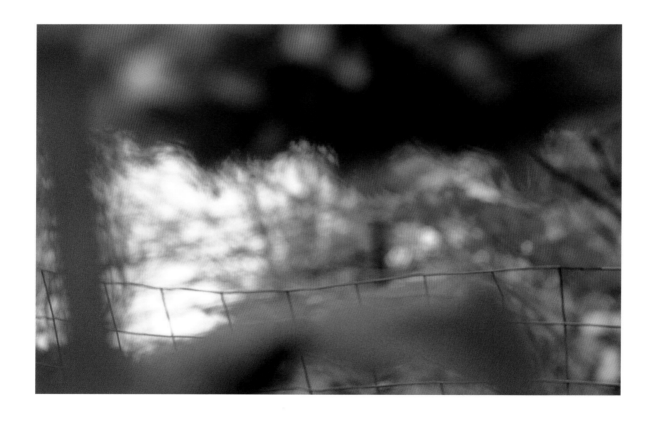

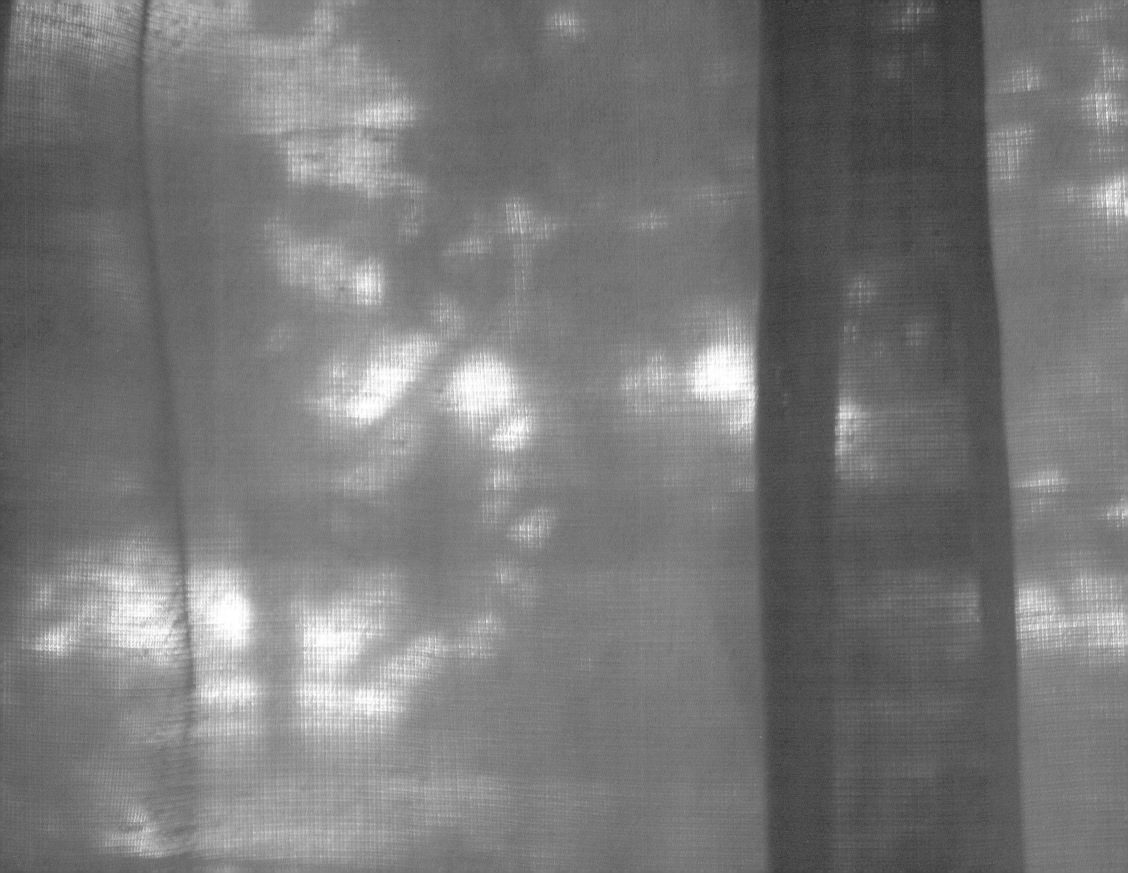

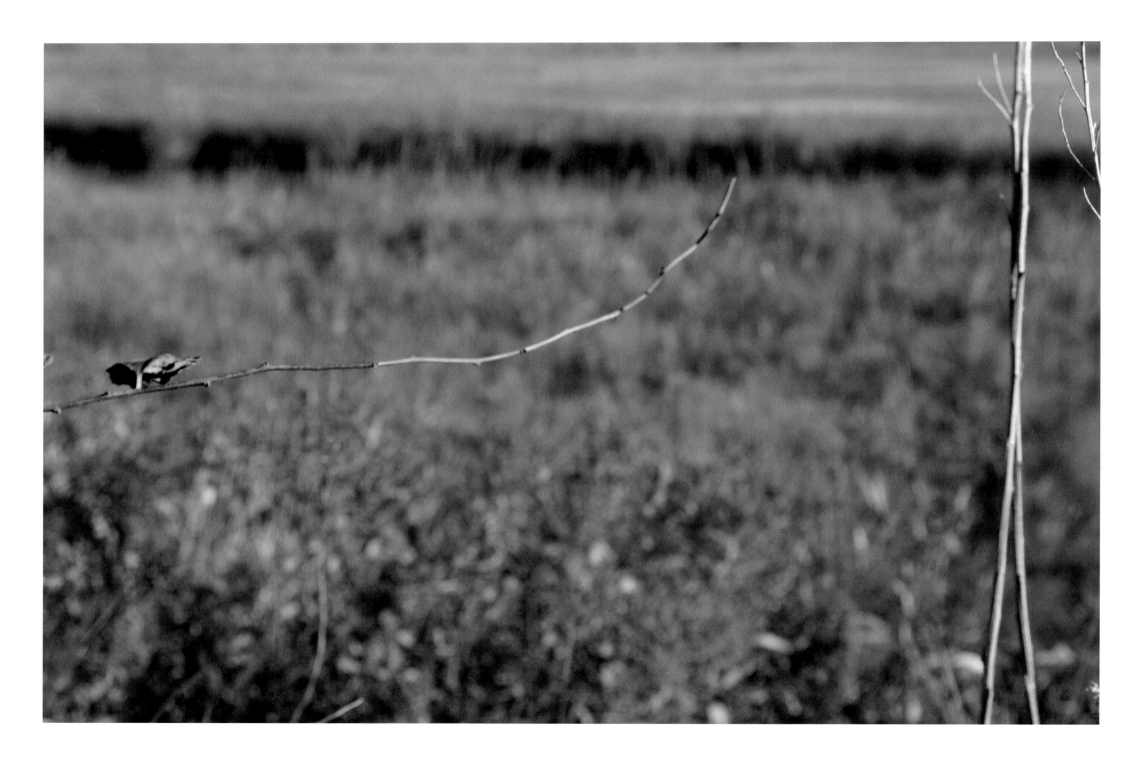

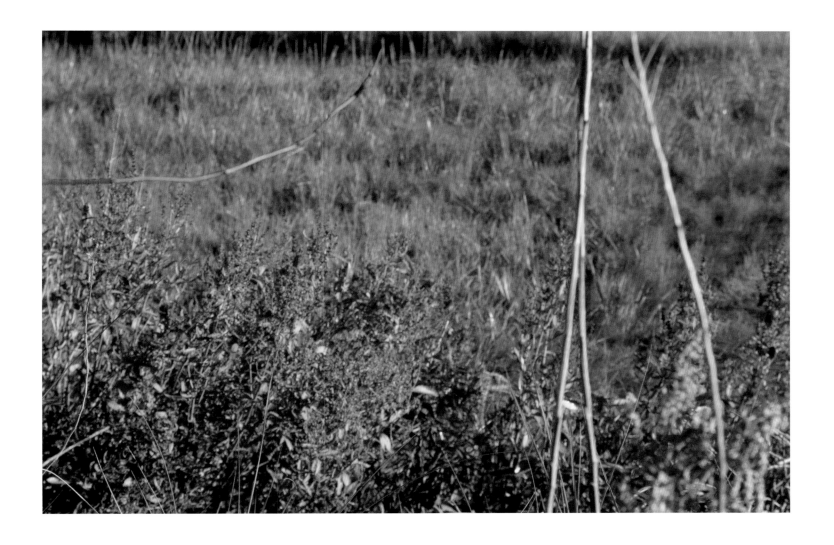

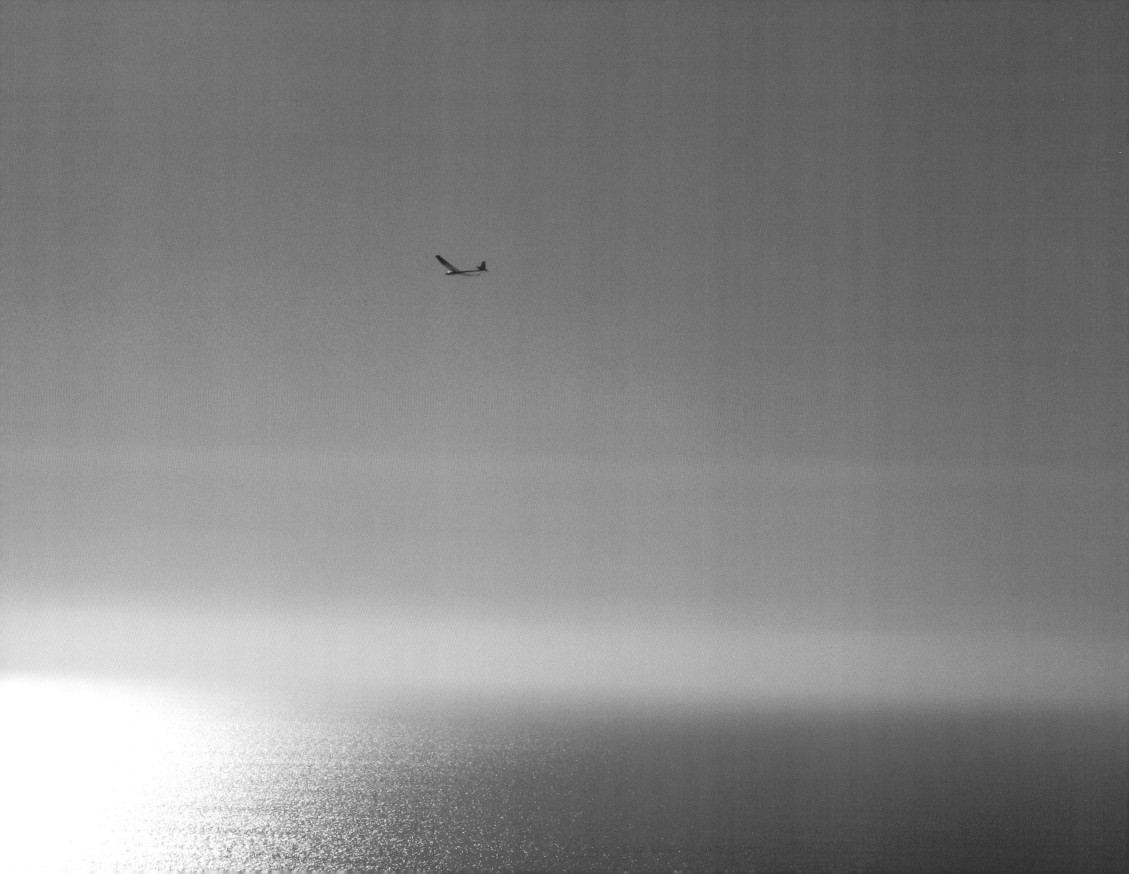

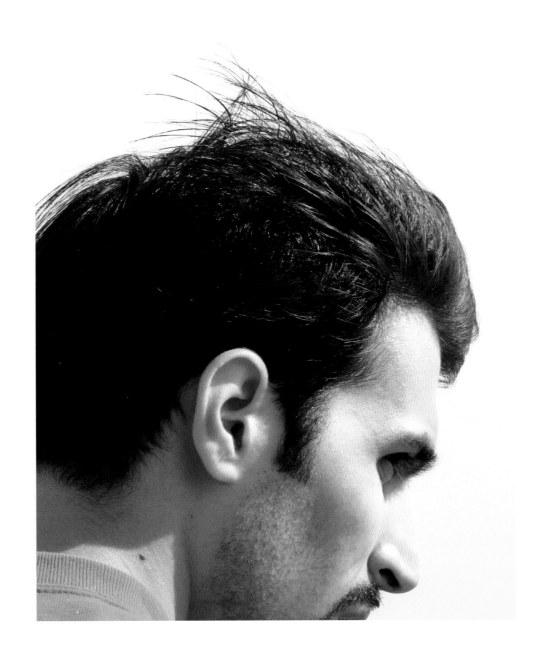

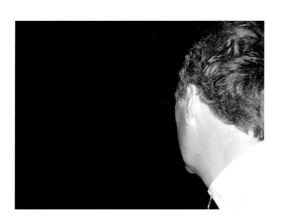

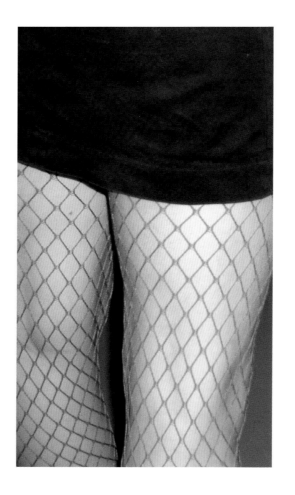

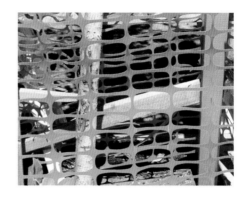

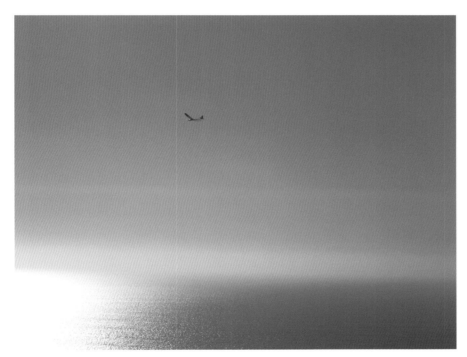

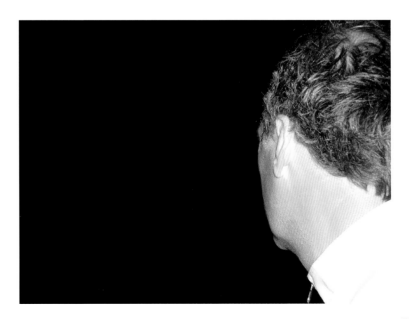

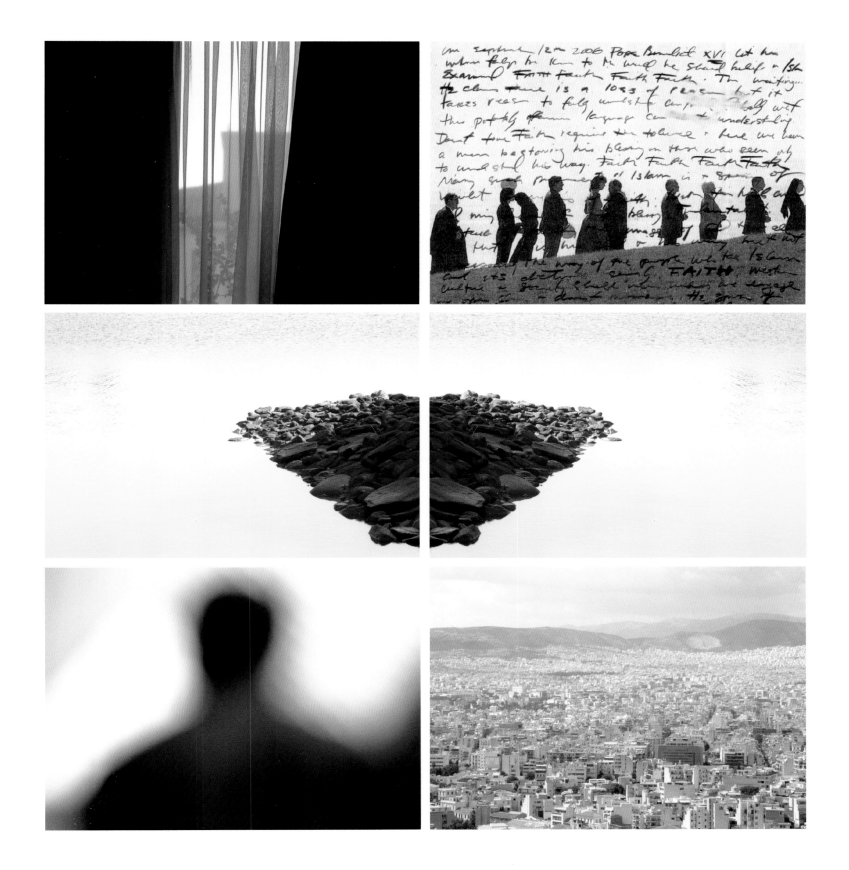

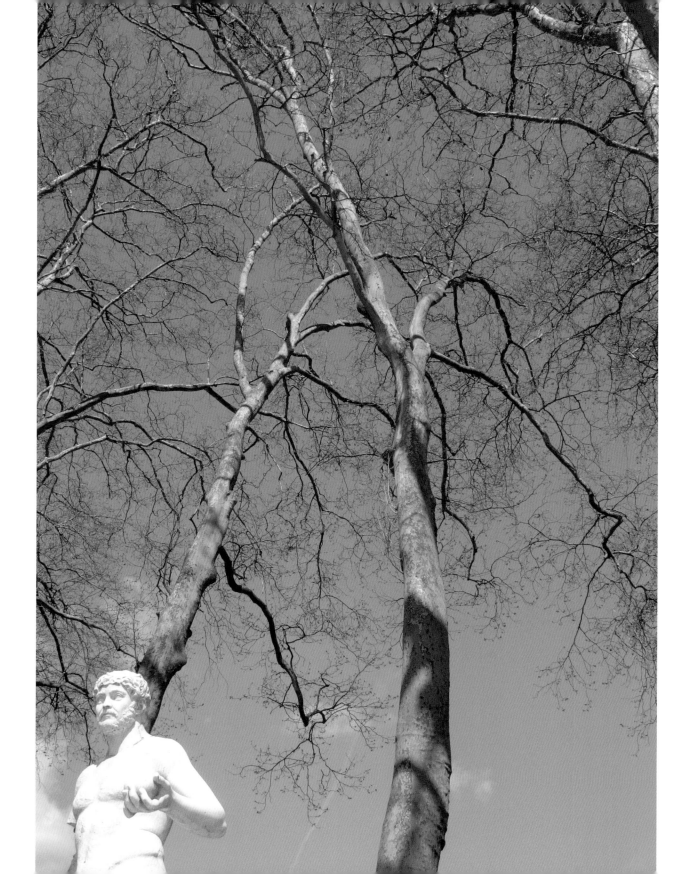

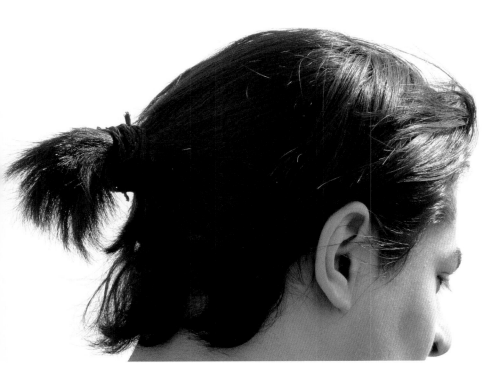

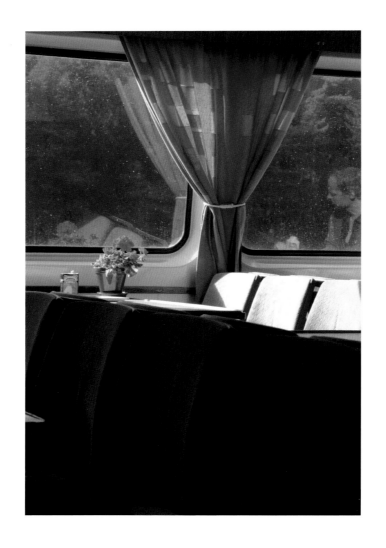

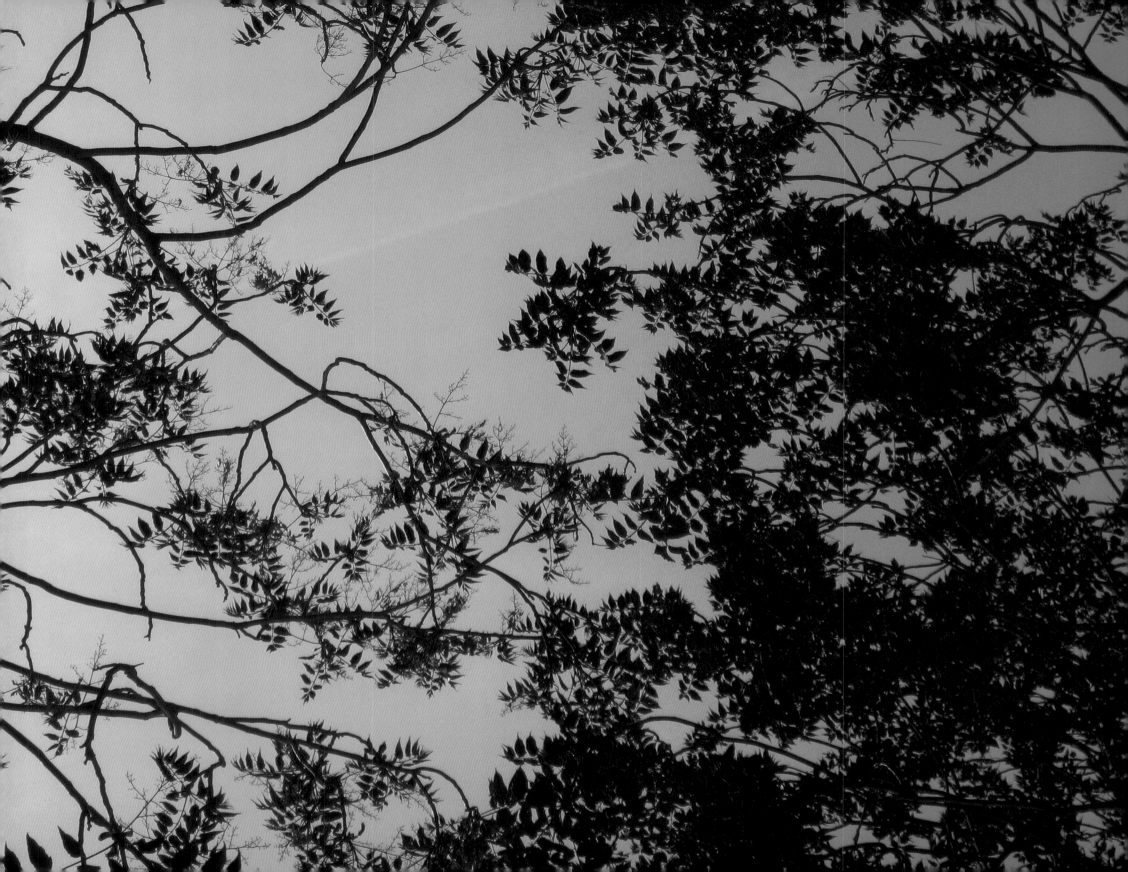

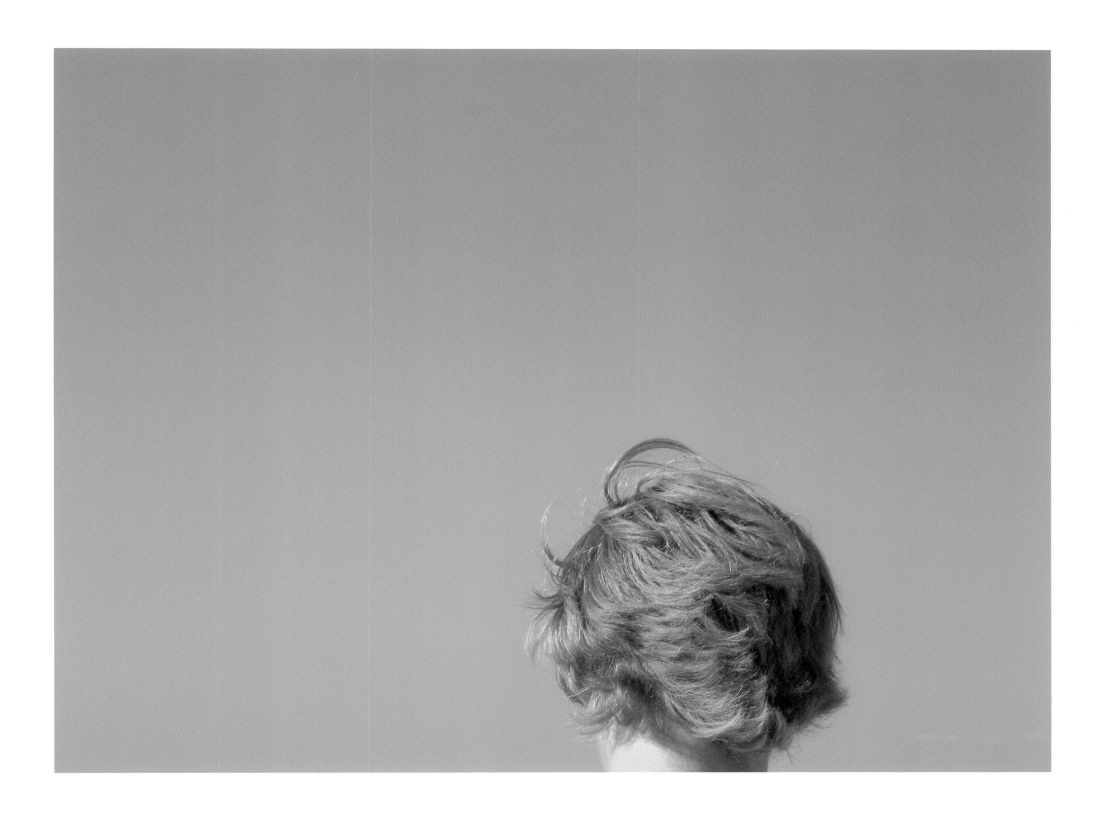

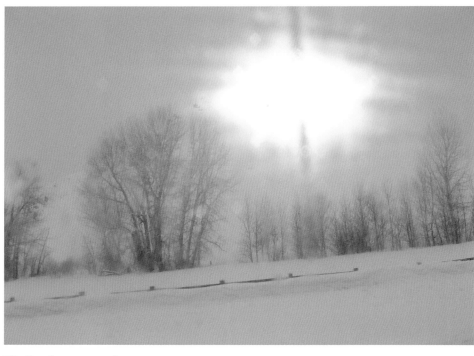

Blinding Snow 2, 2006

Pictures of subtle winter light on a road, a blank space, a tree branch, light gently landing on the back of a young head, another blank space, lens flare and light washing across a pale wall. Sweet as Sandi Haber Fifield's photographs are, they do not readily give up their mysteries. Are they daydreams? Is each image like a carefully selected word building together into a cogent sentence? Are they, like Alfred Stieglitz's meditations on clouds, emotional equivalents? Perhaps these images are the formations of memory itself.

Haber Fifield's photographs from the past five years resemble a kind of memory, flavorful yet elusive. Poetic interpretations call out as if in several tongues from complex arrangements. Haber Fifield requires much of her audience. The combination of ideas is not, as some might expect, a complex puzzle with a solution for us to decipher. She assembles a poetic lexicon of observations in passing. One readily notes the humor, the melancholy, and the irony of her intersecting visions. Her pictures hold fast to that which most photographs give up instantly. It is not easy to tell sometimes what the pictures are about. This allows, or perhaps forces, the viewer to float free and think more abstractly about images and their meanings. If they don't describe something that can be named, what are they doing?
The camera cannot help but be specific. Each image is of a particular time and place. Each is of a unique moment, of a subject that changes even as the lens closes. A photograph clearly points to the singular . . . the vantage point, the moment, the vision, the objects, the lighting. Yet in Sandi Haber Fifield's work we see some generalized images where clarity is often set aside. There is little identifiably specific in an image of open, unobstructed blue sky. None in the blurred light coming through a diaphanous curtain, or the light pattern on a wall. Why employ the veracity of the camera, the specificity of a photograph to identify the generalized sensations of a blurred image of an indistinct subject? Why would one ask photography to describe something that is visceral?

Sandi Haber Fifield's early work gave us blended and overlapped views, stretched long in panoramas of filmic impulses. The fortuitous encounters of images bleeding together precipitated unexpected figures emerging from swirls of color. She found her images in mass media, and in her wandering, chance encounters. Energetic yet meditative horizontals, unencumbered by frame-lines, show a "stream of consciousness" vision, as one might feel observing the world from a moving vehicle. Much of this earlier work was done in India and Haiti, places where the visual cacophony of crowds, colors, and chaos propel such vision. Overlapping crowds of people, and the insistent urban crush created a fusion of inseparable sights.

In a simple but profound statement, Ann Hamilton, the American artist, said, "Everything is about two things coming together." Everything. How a person interacts with a space. How the sperm comes together with the egg. How lips touch. How the rubber meets the road. How the Senate interacts with the House of Representatives. How my finger presses this key. How a parent relates to a child. How age alters skin. How one statement affects a relationship. How one piece of information changes another. Two things coming together.

Life is never as simple or as pure as theory. Ms. Hamilton's "two things" that come together have their own histories. They have accreted other flavors on the way to their meeting. A word may change a relationship between two people but it rarely does so without reference to many other words delivered over time. Skin and time interact in relation to many other conditions of care and genetic predisposition. The finger that strikes this key does so with prepared purpose and fully in relation to previous keystrokes. The two lips that meet have likely kissed others and may bring vastly different desires and expectations to this rendezvous.

Physics tells us that two objects will each exert their own gravitational pull upon one another. The process of arranging images together is not the result of such physical forces but its effects are no less real. When Sandi Haber Fifield balances several images and white space in a grid, why do they seem to generate thoughts only marginally related to their subjects? The rules governing how images affect each other are rarely spoken of and not well understood. How do we learn what an object or a confluence of objects means? How are the names of objects and their appearance bonded? Are the meanings of images as bound to culture as is language?

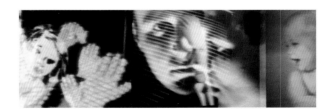

Untitled, 1986

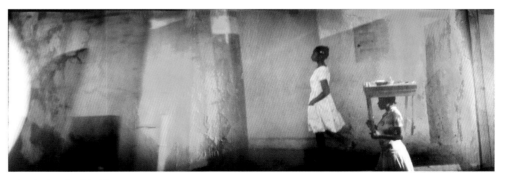

Untitled, 1983 (Haiti)

A young child sees a yellow fire hydrant, her expression brightens, she kicks her feet and raises her hand extending her index finger. "Dis!," she exclaims. Every time she sees this or any other bright yellow hydrant, her response is the same. Cognition is the process of acquiring knowledge and understanding through experience of the senses. Recognition is the identification of something from previous encounters or knowledge. The child has overlaid previous encounters of this wondrous object with her current perception. The recognition is thrilling. Later she will learn to append the locution, "yellow." Still later perhaps she will learn to identify her emotion with "wow." It is the combination of words and images, pictures and emotional states, words and other words that build our perception of life. Pictures never stand completely alone.

Throughout our lives we set one image upon another. We experience a world constructed of images, not used as bricks but rather as translucent washes applied to one another mixing and blending, visions with memories, pictures with words. Visual images arrive entwined with referents. In fact, many have argued persuasively that the referents are inextricable parts of the image, and that the image cannot exist without them. When images intrude upon one another the overlap, the interplay of variables makes chain reactions of potential meanings. The extreme proliferation of images, meanings, mutations, and contradictions are, in fact, what we continually experience from the moment we open our eyes to life. Given the pace of twenty-first-century life, and the many delivery systems for visual information, we soberly recognize that some industries now deliver our eyes to their images rather than, as we might believe, the other way around. Our appetite for images grows but not as fast, apparently as the supply.

Sandi Haber Fifield's photographs challenge traditional camera vision. Does she see differently than we do? Does her camera? One of the primary conceits of photography is the equation of photographic vision with human vision. Photographers speak of their practice as "the art of seeing." The camera's "eye" is commonly referenced, as is the combined sight/insight metaphor. That much of our emotional and intellectual reality is intangible and thus lies beyond the capabilities of our visual apparatus is unquestionable. Many spiritual paths emphasize "seeing with the heart," nourishing our inner vision, our third eye, or the mind's eye, exhorting us to locate truths that hide, often, in plain-sight. Workshops are taught on the enhancement of visual instinct, on developing a heightened capacity for seeing what is "really" there. Much art shares a border with religion and in fact there are elements of the photographic art world that have strategically and sincerely blurred that boundary. The transcendent, however, is no easier to explain in photographs than in words. Photography offers a somewhat different, and not entirely unsatisfactory, tool for identifying the ineffable.

In contrast, many photographic artists will identify that what they value most in their medium is how camera vision and human vision are dissimilar. For them the camera is a tool for extending our vision into realms unavailable to the human eye. They may prefer the moment stopped, the isolated detail, the scene extracted from the continual flow of visual reality. Photographers might explore the ways in which the camera sees things that we cannot; long night exposures, ghostly blurs, amazing infinite depth of focus, contraction of the color world to shades of gray, or heightened contrast. A camera is a Cyclops, denied our binocular vision. If human and camera vision were congruent, it is likely that our passion for the medium would have long ago faded. Sandi Haber Fifield approaches the problem on a different trajectory.

These pictures are very close to how we really see. As our eyes dart around seeking something interesting to focus on, we are unconscious of most of what we see. Much simply does not register. If we consciously touch something, to feel its texture, its weight or its temperature, we are giving our attention to this sensation. But we are always touching something, our clothing, water, air. We are always hearing, and smelling our surroundings, but we take note of it only when we wish to or when something anomalistic is present; lilacs in bloom, rough gravel underfoot, the wail of a fire-truck. This is how our vision works as well. Our minds cannot accommodate our attending to all of the sensual information that we experience. The photographer sifts through the world showing us the moments that resonated with her.

Unlike a camera, our eyes are designed to focus on only one thing at a time. A normal human eye sees a pinpoint of clear focus and concentric circles of progressively blurred information. If one holds one's arm out and focuses on a thumb, all the rest of the visual field is blurred. If we refocus on something in the background then the thumb is no longer clear. Shifting the focus to one side of the thumbnail, the other side of the nail is blurred. Almost everything we see is out of focus. We navigate by continually changing the object of our focus. If you consciously attend to your own focal process you will note that you probably shift focus, approximately every one to two seconds. Our eyes dance about, lightly resting sequentially on a hundred points of focus, but largely ignoring the indistinct periphery. That periphery is where Sandi Haber Fifield finds her nourishment. Her images seem to be rotating in her mind, sequentially attracting her attention. They become her thoughts, occasionally clarified by perfect detail and then drifting off as though on the wings of a memory awakened by a previous image. They are pages in the artist's visual diary.

Sandi Haber Fifield addresses aspects of human vision that few have explored with such dedication. She seems to be floating through a world that is familiar to us and yet we have never seen it this way before. She directs our attention to the things we would almost surely overlook. We might consider a spot of light on a wall or the dripped condensation on a window to be beneath our level of interest. She does not attempt to dramatize these things. We are not being asked to glean a great spiritual meaning from them. Rather she is showing us the context, the living frame within which we live our lives. She is pointing out that we are always navigating a stream of images from which we draw our sustenance. And this is how the stream looks. Like trout in the river, we are watching the oncoming currents, waiting for nourishment to come and attract our attention. Is the trout conscious of water? Is the bird aware of air? A snowy field on a bright day, a jet's contrails making geometric lines, an unidentifiable orb of light, blurred circles of raindrops on a car window, a repeated image of a young woman curled as if in sleep on sand. They do not proceed in an orderly narrative manner; they need not follow grammatical rules. Like memories, these images drift in and out of focus, messages from the edges of her vision, woven together with eloquent threads. They wander elusively in the mind, dissolving one into the others identifying her surroundings and her experience. Here is the artist's realization of everything coming together.

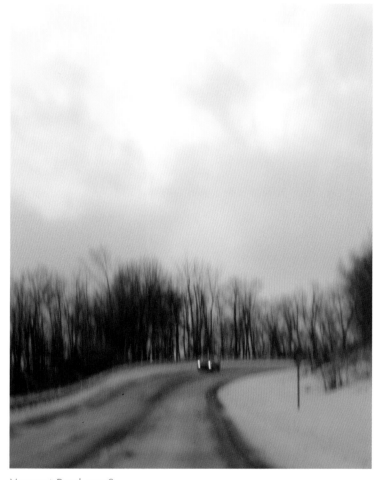

Vermont Road, 2008

Untitled, 1983 (India)

Sandi Haber Fifield navigates the terrain between thinking and feeling with the deftness of a poet. From her appropriated work of the 1980s to her most recent grids and installations, she explores the nature of associative meanings. Through a long engagement with combined imagery, Haber Fifield is a master of the alchemy that results from judiciously mixed elements. Her interest in the individual photograph has less to do with its presumed truthfulness and more to do with its evocative power. Although a lone photograph may distill a potent moment in a family history, it is in flipping through the pages of a family album, back and forth, that a more cinematic experience spools through our heads and touches closer to the truth of a life lived. Not in the literal sense of a narrative completeness, but rather a poetic, suggestive truth, that reveals itself in the space *between* the pictures.

Haber Fifield's use of combined imagery and her exploration of various modes of display, including the diptych, grid and installation, are her tools for excavating this more poetic and relational truth. This book itself is a mode of presentation that perfectly suits her work. It encourages a more intimate participation on the part of the viewer, as we are free to experience the photographs in an open-ended series of relationships, initiated by the artist, but ultimately controlled by us. Moving from page to page, and back again, we discover images that recur in different contexts and combinations – a curtained window, the flight of birds, a turned head, pools of light, a snowy landscape – and we are encouraged to consider the contingency of meaning that is at the heart of Haber Fifield's investigation. With great respect for the authority of the single image, and clearly devoted to the eloquence of meticulous composition, Haber Fifield is not constrained by doctrinaire practice, but moves freely between traditional methods of display and innovative installations of combined imagery. Within these pages she freely mixes moments of focused contemplation with moments of distracted scanning, and in so doing approximates the experience of vision itself. Her body

of work and artistic practice reflects a non-hierarchical, distinctly modern way of seeing – of gathering and synthesizing information about the world – that is in tune with the fluid, participatory, democratic, and prodigiously visual culture of our time. Just as Rauschenberg's silkscreen paintings of the 1960s registered the flicker of the television screen as it began its relentless colonization of American visual culture, Haber Fifield's grids and installations acknowledge the proliferating windows of our digital age.

Haber Fifield's early photographs from Haiti and India challenge the rational apparatus of the camera to explore meanings that reside beyond the discrete frame of a single exposure. Inside the magic box of her plastic and homemade cameras, multiple exposures create a visual stream of consciousness that evokes the layered imagery of dreams. There is a fluidity to these images that suggests a passive state of mind, both conscious and unconscious, open to the flow of life, sensitive to the qualities of place. In this early body of work Sandi Haber Fifield combines fact and memory, dream and reality, to produce a textured record of experience.

As her practice has evolved, the studio has replaced the camera as the magic space of alchemy. Haber Fifield continues to wrestle a remarkable and precarious balance from colliding oppositions. Her large grids and installations are composed of multiple photographs, most culled from her own archive of images, some appropriated from the public domain. There is an important curatorial aspect to Haber Fifield's practice, in which she creates thoughtful and charged relationships between selected photographs. This curatorial practice, in combination with her evolving interest in methods of display, distinguishes her most recent work. The individual photographs are the raw material for these composite works, and in relation they create a visual poetry that is provocative, ambiguous, and extremely engaging. As the poet frees words form the constraints of meaning, so Haber Fifield frees photographs from the constraints of representation. These composite

images suggest more than they depict. A warping takes place between connotation and denotation and resonates against the cool logic of the grid: it is a marvelous play between fixity and freedom. The coherent context of the grid, alluding to the objectivity of conceptual art, is an effective foil for the powerfully intuitive approach of Haber Fifield's practice.

Sandi Haber Fifield walks through the world with her eyes and mind open to the competing possibilities and conflicting perspectives that define our time. She is unapologetic in her romantic pursuit of natural beauty, to be discovered in the perfect shape of a stranger's head, shadows on the wall of an empty room, the light on a landscape glimpsed from a speeding train, a carpet of cherry blossoms in a Parisian park, the Ingresque curve of a sleeping woman's back. The beauty she finds is real, always there out the corner of our eye, never forced or staged, simply caught and held... and then presented. Surprised for a moment by what she shows us, we quickly realize that these are things we have "seen and not looked at," to borrow a phrase from Jasper Johns. But at the same time, Haber Fifield addresses the ugly realities of our global world that we see but often choose to not look at: environmental degradation, religious intolerance, xenophobia and genocide. Moving between the pastoral and the political, Haber Fifield brings to all her work a refined sensitivity to formal beauty. Whether it is intimate views onto familiar green landscapes through her own parted curtains, or distant views of foreign cities with their look of otherness, the foreign and familiar, the lyrical and mundane are brought into balance. The soft focus of personal memory contrasts with the clarity of material fact, often in a single work. Haber Fifield embraces the inconsistencies that modulate our lives. There is a play of opposites at work in many of her large grids: inside and outside, beautiful and ugly, nostalgic and modern, casual and formal, actual and imagined, invented and appropriated, captured and staged. But the inherent discord is offset by compositions of the utmost integrity.

In *Sewing Class Cancelled*, a picture appropriated from the news media, with its presumption of journalistic truth, is stripped of objectivity by the artist through altered context and manipulation. She will often write on the appropriated image in her own hand an inflected version of the story, woven together from fact, feeling and imagination, to excavate a more subjective truth. The borrowed image is the starting point for an artistic process that is a lot like life: Haber Fifield culls through her image bank as we scan our imaginations, following lines of thought that are rarely linear, exploring connections and chasing memories, drawing on books read, films seen, meals shared, startling flashes of insight, and mundane walks with the dog. In speaking about her combined imagery, Haber Fifield has said: "I might read something that moves me, and then begin to process it visually by scanning through my book of hundreds of images and trying to make visual connections that resonate. Sometimes the connections are purely formal and other times they are content based – to make it work as a whole, both must

come together – kind of like building a house from the inside and outside at once." In her work these connections often take the form of things seen along the margins, but rarely looked at: a car speeding off - the driver obscured, an ambiguous shape on an incidental wall with its history of decay, a spectral glimmer of light in the distance, a torn seam in a fabric of lavish beauty. Meaning accumulates in the seams between the images – as it does in life. Held together by a formal rigor, the disparate moments suddenly cohere, and propose a more nuanced truth than we might have considered.

Haber Fifield's grids and installations suggest the possibility of narrative. We sense that a story is being told, but its meaning is beyond reach. There is a filmic quality to the work, with its shifting focus, sequencing of frames, recurring characters, distinctive settings, and incorporation of movement through time and space – a quality that encourages our search for story. In *A Simple Scarf*, the

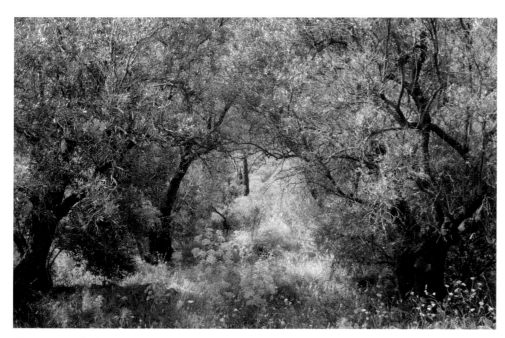
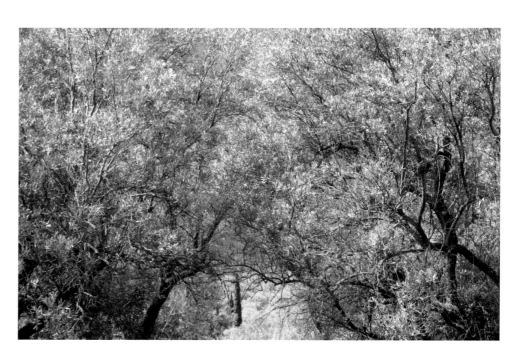

Clearing 1 and Clearing 2, 2006

characters slide in and out of focus. The plotline moves from desolate landscape to sprawling city. The viewer's eyes move from frame to frame as we struggle to focus on selected details that may hold clues to unraveling this mystery. In one frame we find writing itself, encouraging us to read, to decipher. But we cannot: the writing avoids elucidation. "A simple scarf," "injustice," "beauty," "accused": provocative words that reveal themselves, foiled by others, blurred and illegible, that thwart the possibility of a coherent reading. And at the center of this composition is the frame with the least amount of information – a vague and ambiguous image. Our eyes are forced to the margins. We begin again, moved by the formal rhythms of the composition. The artist activates our vision. We are conscious of how vision gathers information and creates connections in an effort to construct meaning. Aided by memory and association, we piece together our own narrative.

When working in the diptych format, Haber Fifield often plays with shifting moments of perception that sensitize us to our own experience of vision. In *Clearing 1*, the viewer has the sensation of moving down a path towards a thicket of old olive trees in the silvery light of a Mediterranean landscape. Just ahead, a low arcade of branches perfectly frames a glimpsed view of a grassy clearing and blue sky beyond, promising release. Our pace accelerates and suddenly we are brought up short, our heads thrown back, to marvel at the miracle of light as it flickers through the trembling foliage in *Clearing 2*. Our eyes move from ground to sky, back and forth, up and down, absorbing the details of place, acutely aware of the cumulative nature of perception, and the ways it shapes meaning.

In Haber Fifield's most recent work with photographic installations, she expands her inquiry into the nature of associative meaning and the act of seeing. When she installs photographs on opposite and adjacent gallery walls in constellations of information, she activates not only vision, but the space itself. Through the combination of blurred and focused images, broad shifts in scale, and thoughtful placement beyond a single sightline, she engages the viewer physically with the work: we now move through the gallery space, head and body as well as eyes. The installations provide for an open-ended, participatory experience, with many points of entry, and limitless interpretive possibilities. Like internet social spaces, with their impromptu parade of ad hoc images and disembodied bytes of information, these installations are democratic and dynamic, echoing the qualities of contemporary culture. There is a provisional quality to the installations themselves, with the unglazed prints simply pinned to the wall, available for rearrangement at any moment, like memories so quick to realign themselves, in the service of another story.

Sandi Haber Fifield's photographs, grids and installations propose a more poetic and relational truth. They provide an experience of vision that is powerfully familiar, but evanescent. The work captures not a moment itself, but the feeling of many moments: reverie, elation, intuition, revelation, and frustration. These are moments that define a life. From the soft focus of unpopulated spaces to the clarity of journalistic fact, her work embodies the complexities of a life lived. It reflects the relativity of modern experience in a global world where nothing is fixed and truth shifts at the speed of broadband. Haber Fifield's photographs capture the experience of walking through the world, directed, like the artist herself, but acutely attuned to the moments of beauty and quiet events that unfold along the edge of vision.

LIST OF WORKS

SANDI HABER FIFIELD

Sandi Haber Fifield has widely exhibited her photographs throughout the United States. She has been included in exhibitions at The Art Institute of Chicago, The DeCordova Museum, The Museum of Modern Art, The Oakland Museum, The St.Louis Art Museum, The Carpenter Center for the Arts, The National Museum of American Art, The Southeast Museum of Photography and The Museum of Contemporary Photography in addition to numerous gallery exhibitions. Her work is held in several private and public collections including The George Eastman House, The Brooklyn Museum, The High Museum, Los Angeles County Museum, and MoMA. Haber Fifield's photographs have been published in *Fabrications* by Anne Hoy, *Picturing California* by Therese Heyman, *Defining Eye: Women Photographers of the 20th Century* and *The Photography of Invention* by Merry Foresta. *Walking through the World* is the first monograph devoted solely to her work.

KAREN SALSGIVER Principal of the firm Salsgiver Coveney Associates in Westport, Connecticut, whose award-winning designs have appeared in *Communication Arts*, *I.D. (International Design)*, *Print*, *Graphis Branding*, *Graphis Design Annual*, *AIGA Graphic Design U.S.A.*, and *AR100*. Her work is included in the collections of the Rare Book and Manuscript Library at Columbia University, the Rare Book Room of Sterling Library at Yale University, and in the archives of the American Institute of Graphic Arts (AIGA).

TOM O'CONNOR Art historian, writer, and arts consultant. Mr. O'Connor is a member of the Art History faculty at the School of Visual Arts in New York, where he has taught for the past twenty-five years. He is developing a visual arts program for a non-profit exhibition space to open in Stamford, Connecticut where he will be Director of Exhibitions

ARTHUR OLLMAN Founding Director of the Museum of Photographic Arts in San Diego, California, where he was responsible for the curatorial and artistic vision of the institution for more than twenty years. Mr. Ollman is the author of numerous books, his most recent being *The Model Wife*. He is presently Director of the School of Art, Design, and Art History at San Diego State University.

ACKNOWLEDGEMENTS

One of the great pleasures in finishing *Walking through the World* is being able to thank the many people who have helped along the way.

There are three extraordinary individuals to whom I am deeply indebted: Karen Salsgiver, my dear friend and designer, your talent is evidenced on every page. You graciously coached me with uncompromising vision as I navigated unfamiliar terrain. Tom O'Connor, professor of Art History at the School of Visual Arts, for knowing and understanding my work and for giving language to my images; I am profoundly grateful for your wisdom. Arthur Ollman, founding Director of the Museum of Photographic Arts; your early encouragement in my photographic journey has come full circle with your participation in this project—I deeply appreciate your thoughtful words. I have relied upon the collective advice of many others throughout the years:

I recognize the gifts of those teachers who helped me discover the path to my work. From my time in Rochester, I am thankful to Charlie Arnold and John Pfahl at the Rochester Institute of Technology. A special thank you to Owen Butler, for both the memorable discipline you gave your students and the poetic language you have brought to photography. And to Nathan Lyons, founder of Visual Studies Workshop, whose notion of sequencing continues to guide my work.

At Charta, I would like to thank Francesca Sorace and Giuseppe Liverani for immediately embracing this project, and to Filomena Moscatelli as well as the entire Charta team for the exceptional care that went into this publication.

Joel Sternfeld . . . for the inspiration of your work and for generously introducing me to Charta.
Alice Rose George . . . for your editorial magic.
Lauren Ryan . . . for sharing your heartfelt connection to my photographs.
Richard Klein . . . for your unsparing endorsement early on and for honoring my photographs with your insightful comments.

Many thanks to my gallerist Jacquie Littlejohn at Littlejohn Contemporary for your keen eye and ongoing support of my work.

I have also depended upon the kindness and advice of Katie Block, Jill Cohen, Dan Cooney, Helen During, Linda Fiske, Judy Hottensen, Rachel Lafo, Mary Ellen Mark, Ellen Miller, Laurence Miller, Yancey Richardson, Eric Safyan, Michael Sand, Julie Saul, Charlotte Strick, and Rick Wester.

My treasured friends and family with whom I shared the dream of this book, you are too numerous to mention but you steadily cheered me on. My mother Bryna Haber and my brother Jay, despite the 3,000 miles, you are always with me. George Fifield, thank you for your exacting eye and thoughtful advice. To my son Ben, I rely on your insights for an unexpected perspective, delivered always with warmth and humor. To my daughter and beautiful muse Jocie, thank you for not throwing me out of your room every time I approached with my camera and for letting me in so graciously. And last here but always first, my husband John, whose endless well of patience and kindness (and the best tech support imaginable) insures that I am never lost on my walk through the world—all my love.

Design
Karen Salsgiver

Design Coordination
Daniela Meda, Gabriele Nason

Editorial Coordination
Filomena Moscatelli

Copyediting
Emily Ligniti

Copywriting and Press Office
Silvia Palombi Arte&Mostre, Milano

US Editorial Director
Francesca Sorace

Promotion and Web
Monica D'Emidio

Distribution
Antonia De Besi

Administration
Grazia De Giosa

Warehouse and Outlet
Roberto Curiale

Cover
Untitled, 2008

Edizioni Charta srl
Milano
via della Moscova, 27 - 20121
Tel. +39-026598098/026598200
Fax +39-026598577
e-mail: edcharta@tin.it

Charta Books Ltd.
New York City
Tribeca Office
Tel. +1-313-406-8468
e-mail: international@chartaartbooks.it

www.chartaartbooks.it

© 2009
Edizioni Charta, Milano
© Sandi Haber Fifield for her works
© The authors for their texts

To find out more about Charta,
and to learn about our most recent publications, visit

www.chartaartbooks.it

Printed in January 2009
by Tipografia Rumor, Vicenza
for Edizioni Charta

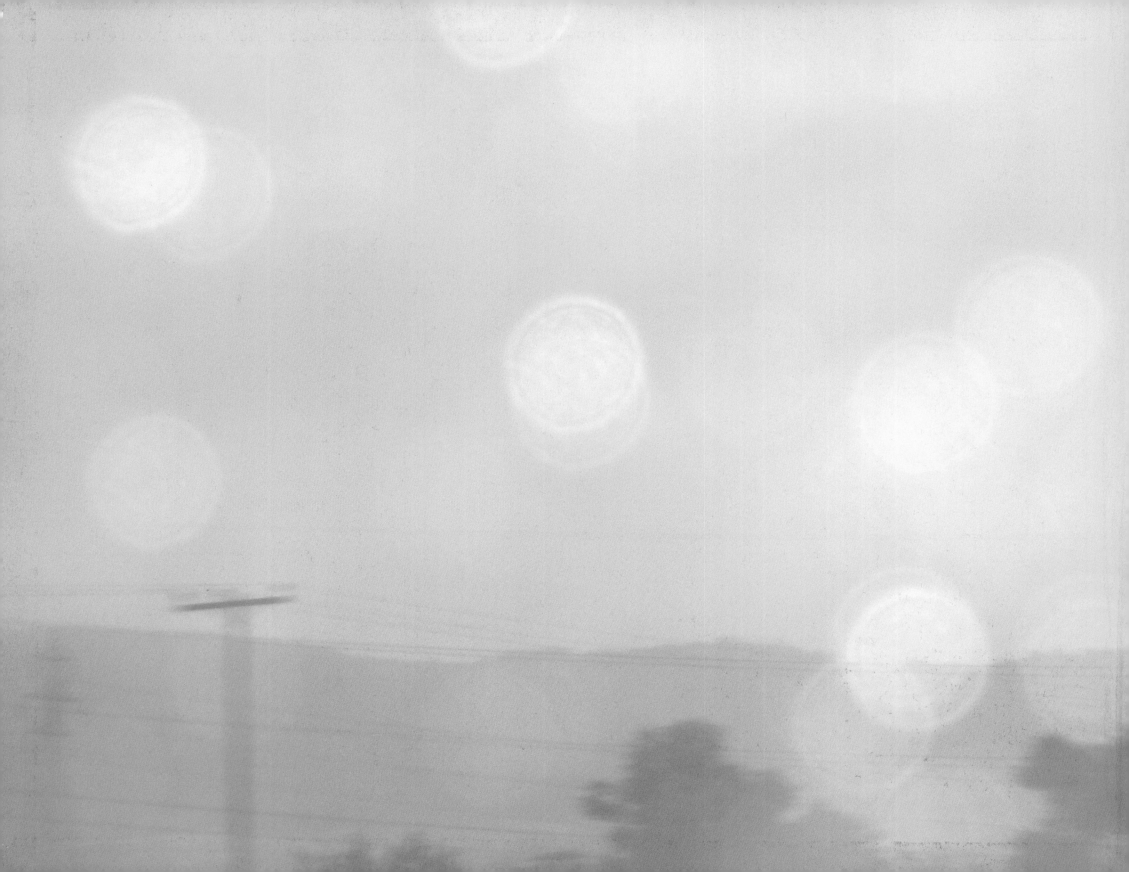